Display

Display
recent installation
photographs from
London galleries
and venues

edited by Pablo Lafuente

Rachmaninoff's

Display
recent installation photographs from London galleries and venues
edited by Pablo Lafuente
© 2005 Rachmaninoff's

ISBN 0-9548240-2-4

Published 2005 by
Rachmaninoff's,
Unit 106, 297-301 Kingsland Road, London, E8 4DS
T +44 (0)20 7275 0757
www.rachmaninoffs.com

Printed by specialblue, London

Foreword

This book intends to work as a survey; not of art, the people who make it or the places where it is shown; but of the ways art is shown in those places, and how those ways are registered. It is made with the understanding that it is not just artists who make things (objects, images, events...) for galleries to show and people to see, but that those who select and display the work, as well as those who take pictures of it, also make the artwork what it is.

A dominant Modern narrative characterizes the artwork as an object originating in the artist's creativity. According to it, the result of that creativity is an autonomous entity, an object that, while materialising the highest values of its time, functions on its own, independently from its origin, use, context or value. Against it, this book stresses the role that the context of presentation plays in the experience of art. This is made not with the intention to reduce the analysis of the art object to a sociological study, but on the awareness of the historical (and, therefore, contingent) character of the conditions that determine the modes of production and reception of art.

What we understand today as art – as different from the fine arts – is a set of practices that are articulated by a discourse that combines two contradictory elements: a claim to autonomy, and a political promise. Following Jacques Rancière's reading of Friedrich Schiller's *On the Aesthetic Education of Man in a Series of Letters*, the aesthetic experience, in the Romantic movement, is understood as a moment of suspension of any other experience.[1] But the possibility of this momentary interruption of the order of the world implies that the relationship the subject normally establishes with the world, and his position within it, is not necessary. If that is the case, the artwork is, then, political, in the sense that it affirms a possibility of change, by questioning the way the world is organised, the modes in which things can be said and the positions from which they can be stated. That combination of autonomy and heteronomy (art's political promise) characterises the discursive regime that Rancière calls aesthetic, and it is this contradiction that is at work within every aspect of contemporary art production, including exhibition display and its visual documentation.[2]

When a work is placed within a gallery environment – or outside of it – it is set in relationship to a space, to other works, to light, to time and to a viewer. It is also placed within the wider context of a system of cultural values and of exchange of merchandise. Counter to any essentialist conception, these contextual relations determine the aesthetic experience in a way that is not merely external: they produce the artwork.

This also applies to visual records of those displays. Installation photography not only registers the way works are presented, it re-presents them to the same or a new audience (potentially larger) through a variety of visual codifications. These, whether they claim to be objective documentations or acknowledge a subjective perspective, are always based on diverse notions about the nature of the artwork. As collector and photographer Wilhelm Schürmann says in Stephen Prina's *We Represent Ourselves to the World*, 'the photographer's point of view could and does open up a specific view of the art.'[3]

In that exhibition and book project, Prina selected an image from every exhibition held at Galerie Max Hetzler from 1974 to 1991. The result was an

analysis of installation and documentation of art, but also a history of a gallery. This book looks at the same issues, but by focusing on a larger scene – London – in a certain moment in time – December 2003 to the date of publication. 108 images have been selected from the archives of 73 contemporary art venues and organisations based in the city, related to exhibitions and events that took place between those dates. The selection procedure had three stages: in the first place, a list was made of all contemporary art venues operating in the city during that time. Around one hundred of these were contacted, and asked to provide a number of exhibition shots from several of their exhibitions. The images received were selected according to two criteria: that they were representative of a diversity of approaches, and that their high digital quality was good enough for the printed format. Finally, the material was ordered in a way that was intended to establish contrasts, parallelisms and continuities.

The selected photographs range from the white cube – with no windows and diffuse light, in which the world is kept outside and the viewer is absent – to images in which that purity is disrupted: by a ray of light, by the enhanced presence of the architecture or infrastructure of the exhibition space, or by the participation of the public 'using' the work.

In a project of this nature, the selection process is based entirely on the perspective of the selector, not just in the choice of venues and images, but also in the articulation of the material. That means the picture it offers is neither comprehensive nor definitive. The book simply maps a set of installation and documentation practices with the intention of providing the opportunity for a wider reflection on the implications that those practices have for the status of the artwork. The aim is not to pose the questions 'How do you display an artwork correctly?' or 'How do you accurately document it?', but to ask 'What do you do to an artwork when you place it next to another one, under a certain light, with or without visual noise, and independently or in relation to the space that surrounds it and the people who experience it?' and 'What happens when you photograph that display?'

Pablo Lafuente
25 July 2005

[1] Friedrich Schiller, *On the Aesthetic Education of Man in a Series of Letters*, (Oxford: Clarendon Press, 1967)

[2] In books like *The Politics of Aesthetics* (London: Continuum, 2004), *Malaise dans l'esthétique* (Paris: Éditions Galilée, 2004) or *Le Destin des images* (Paris: La Fabrique éditions, 2003)

[3] Stephen Prina, *We Represent Ourselves to the World* (Los Angeles: UCLA, 2004)

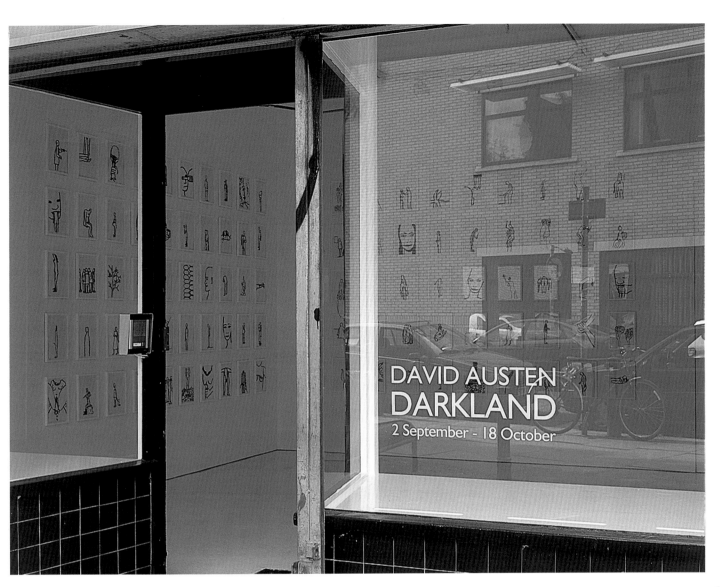

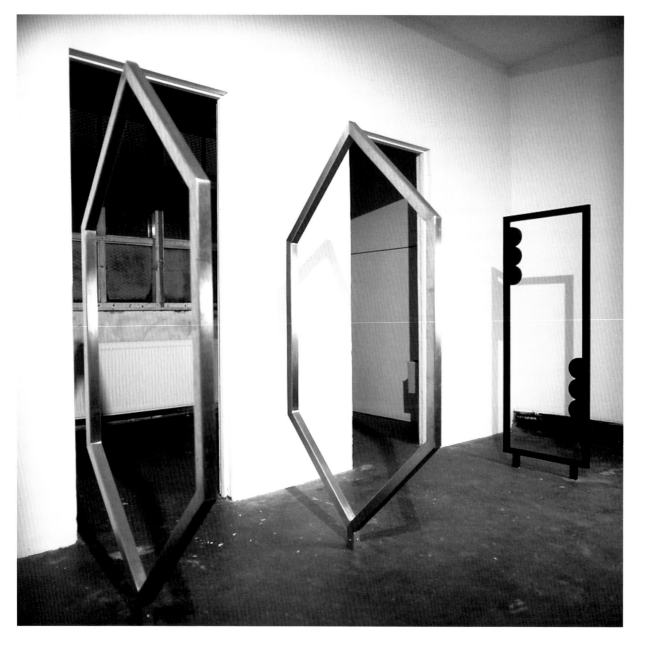

1. (previous page) David Austen, 'Darkland', Peer, 2004
2. (left) Nicole Wermers, 'Katzensilber', Millers Terrace, 2004
3. (right) 'Strange Weather', Modern Art, 2004

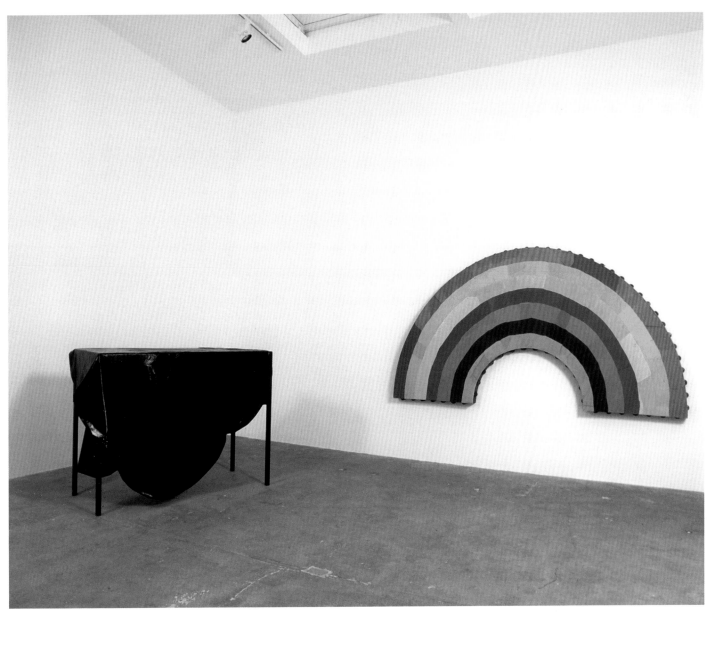

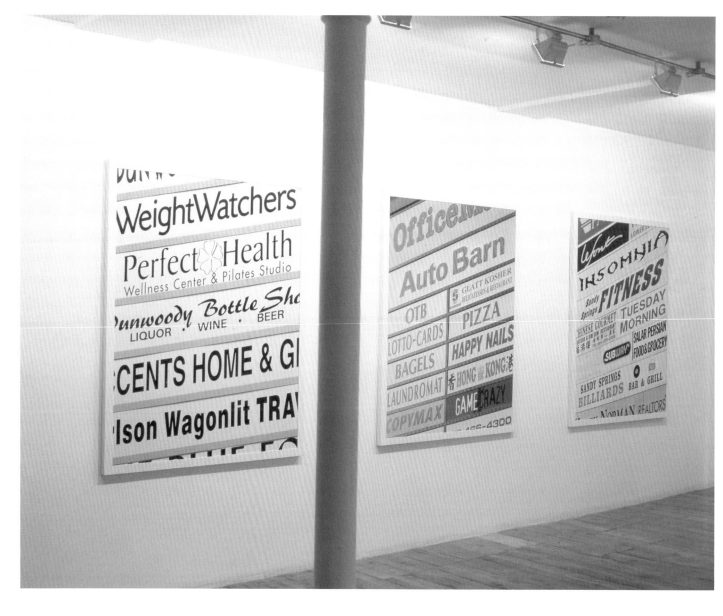

4. Roe Ethridge, 'County Line', greengrassi, 2005
5. Don Brown, Sadie Coles HQ, 2004

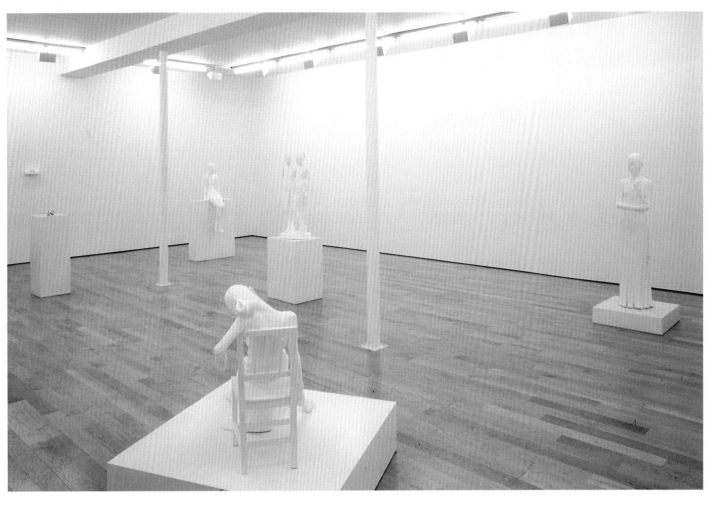

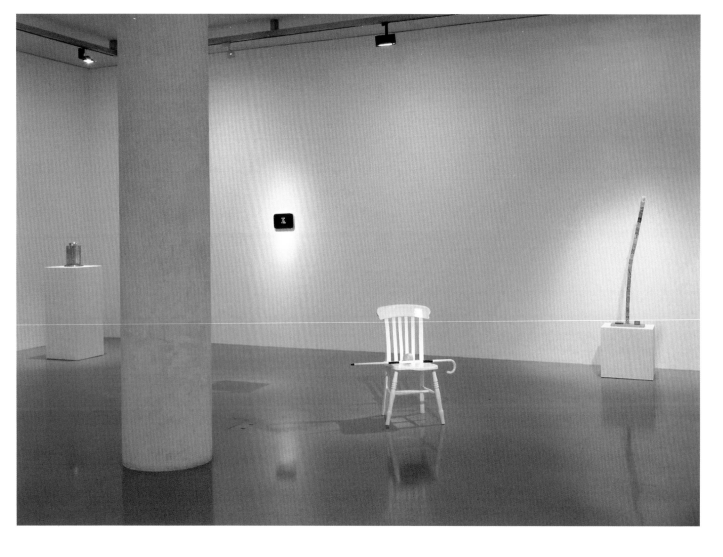

6. George Brecht, 'Works from 1959-1973',
Gagosian Gallery, 2004
7. Glenn Brown, Serpentine Gallery, 2004

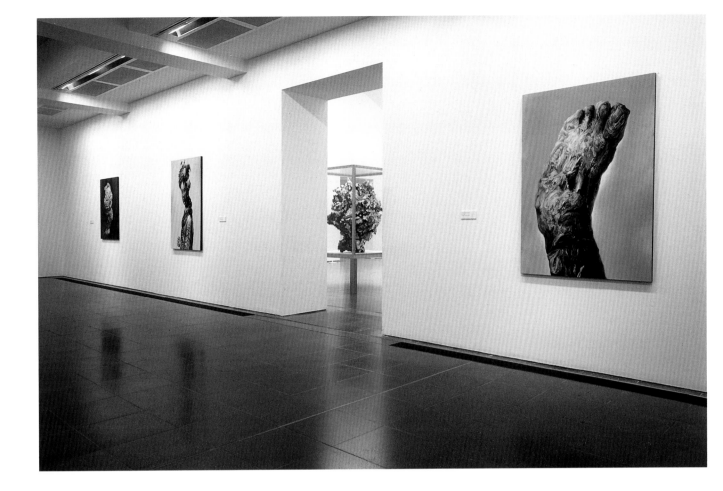

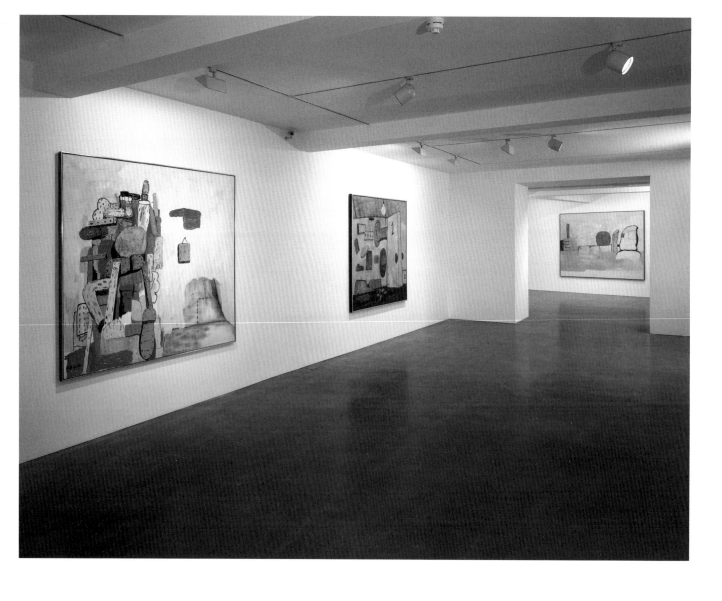

8. Philip Guston, Timothy Taylor Gallery, 2004
9. Roy Lichtenstein, 'Last Still Life',
Bernard Jacobson Gallery, 2004

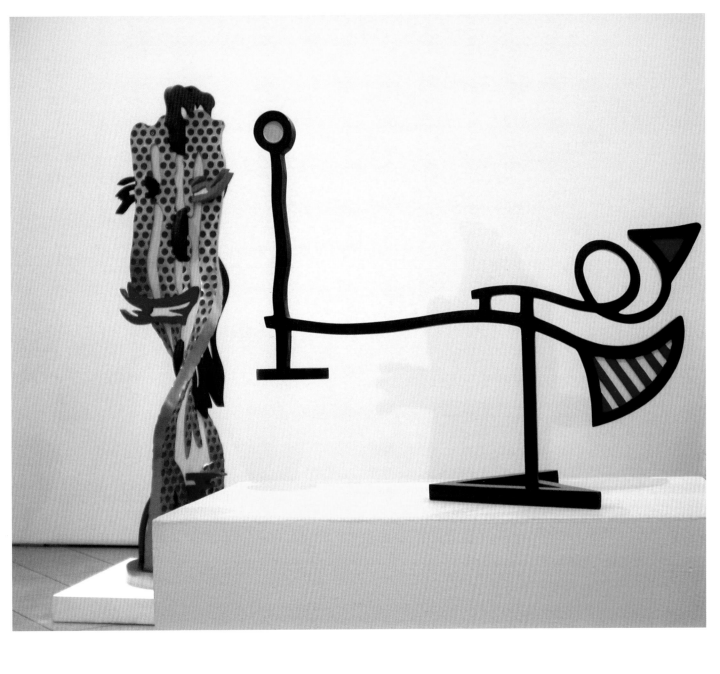

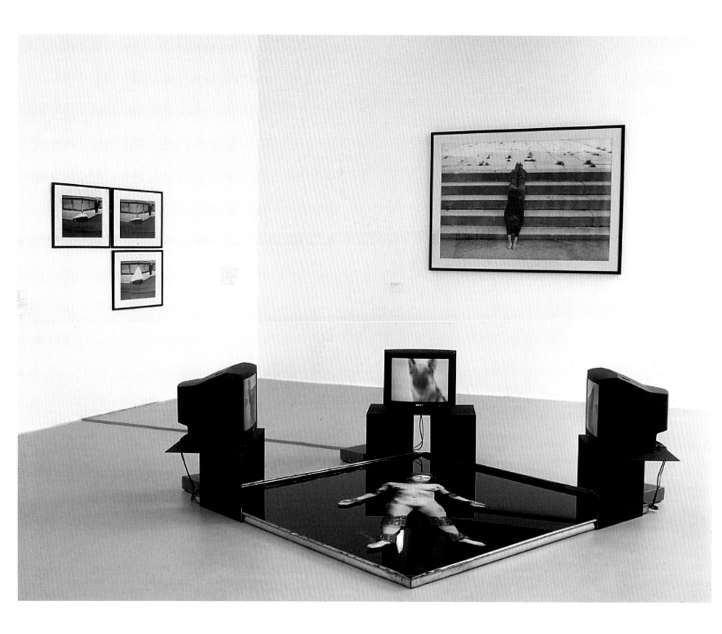

10. Valie Export, Camden Arts Centre, 2004
11. Sherrie Levine, 'Loulou', Faggionato Fine Art, 2004

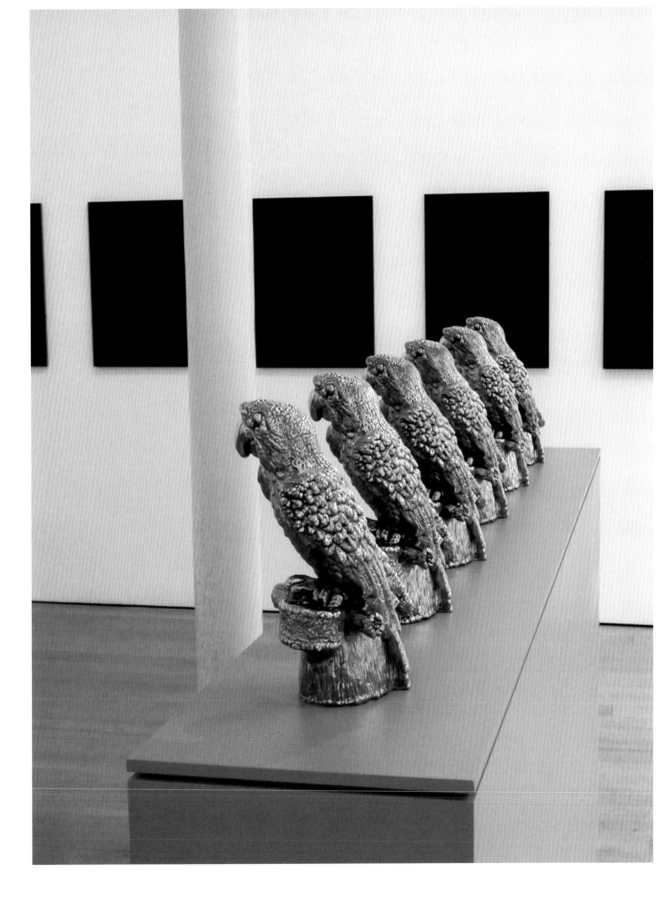

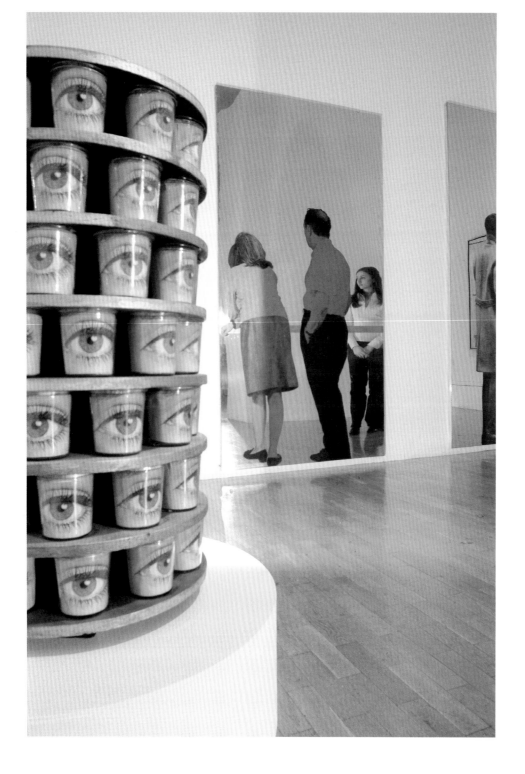

12. 'Faces in the Crowd', Whitechapel, 2004
13. 'Paper', emilyTsingou gallery, 2004

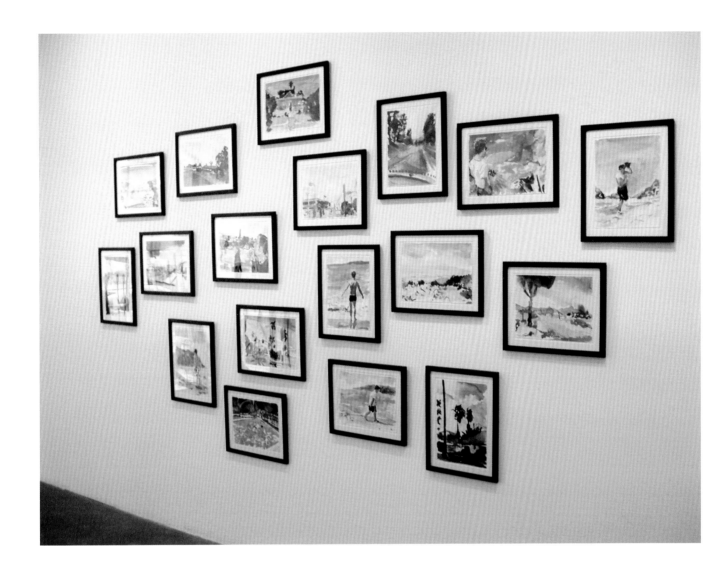

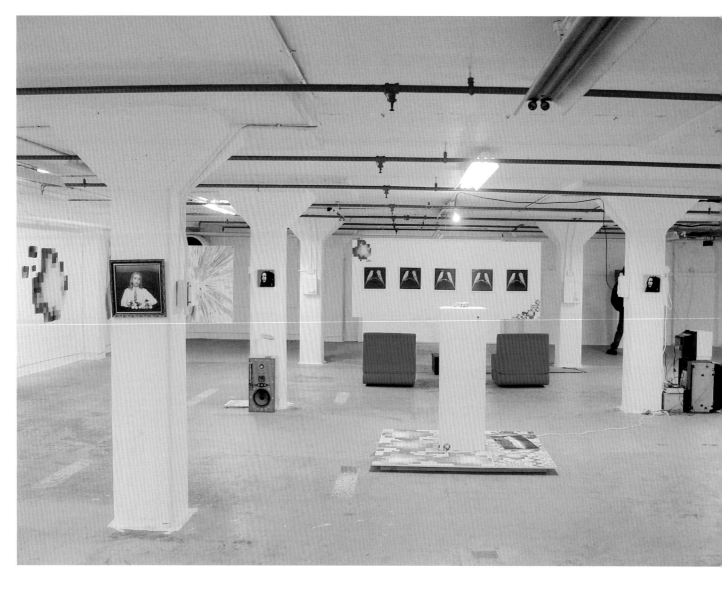

14. 'DaDaDa: Strategies Against Marketecture',
temporarycontemporary, 2004
15. Sarah Morris, 'Los Angeles', White Cube, 2004

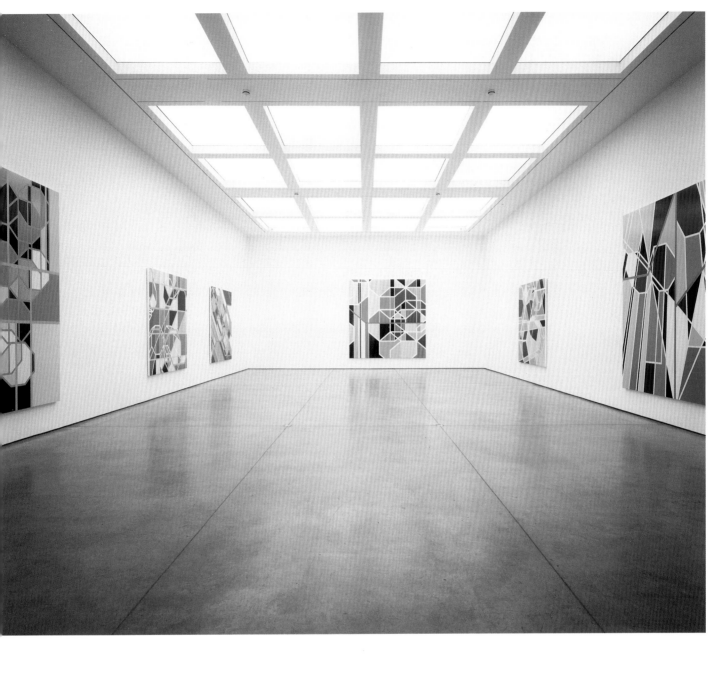

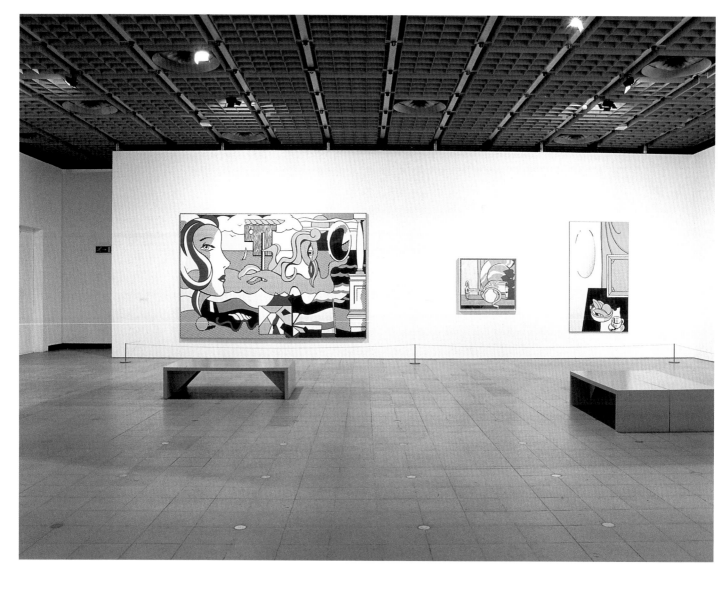

16. Roy Lichtenstein, Hayward Gallery, 2004
17. 'Robert Mapplethorpe curated by David Hockney',
Alison Jacques Gallery, 2005

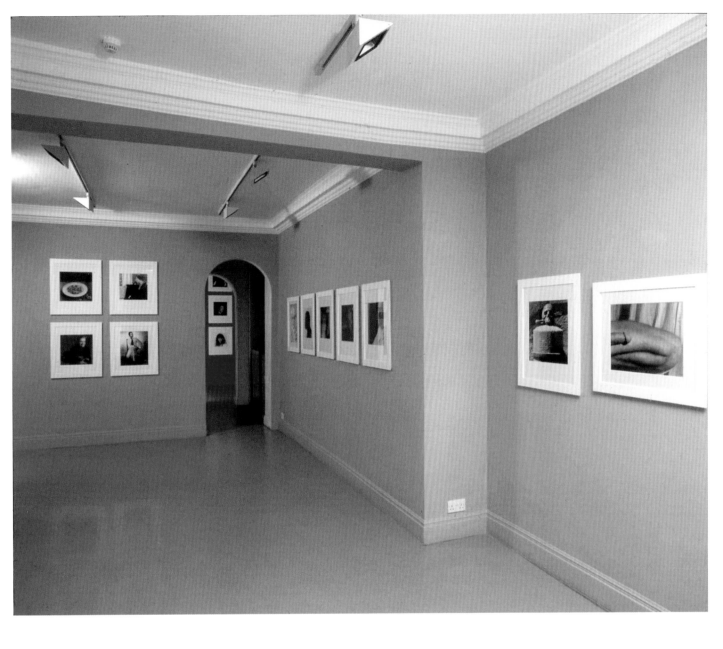

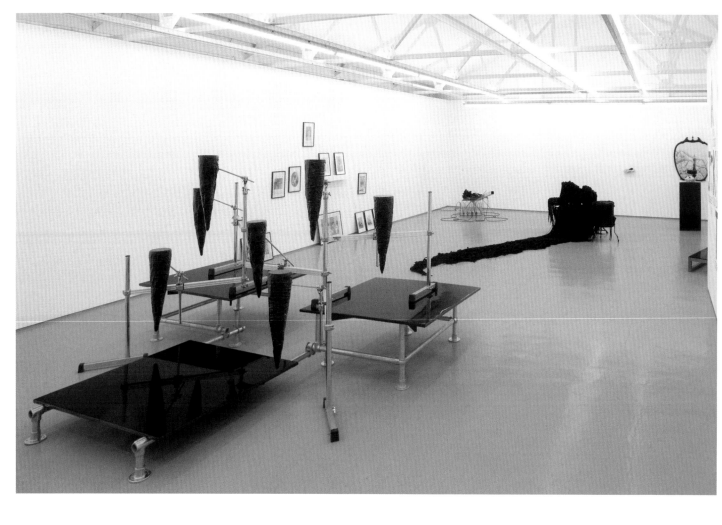

18. 'The Black Album', Maureen Paley, 2005
19. Tom Gidley, STORE, 2004

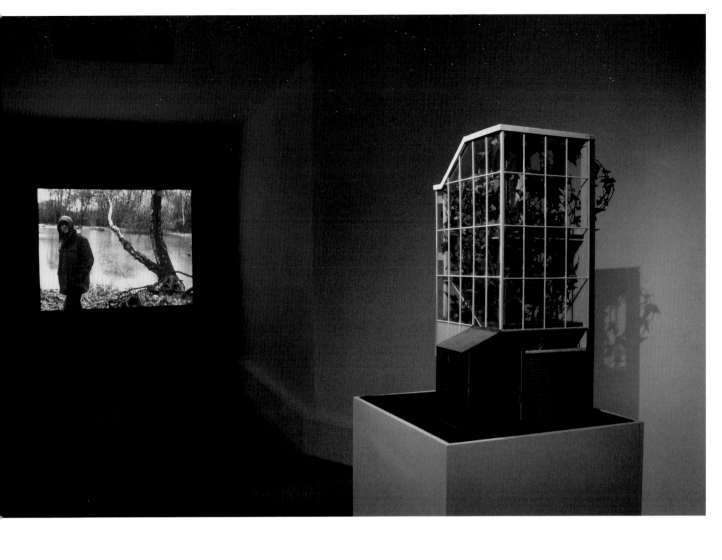

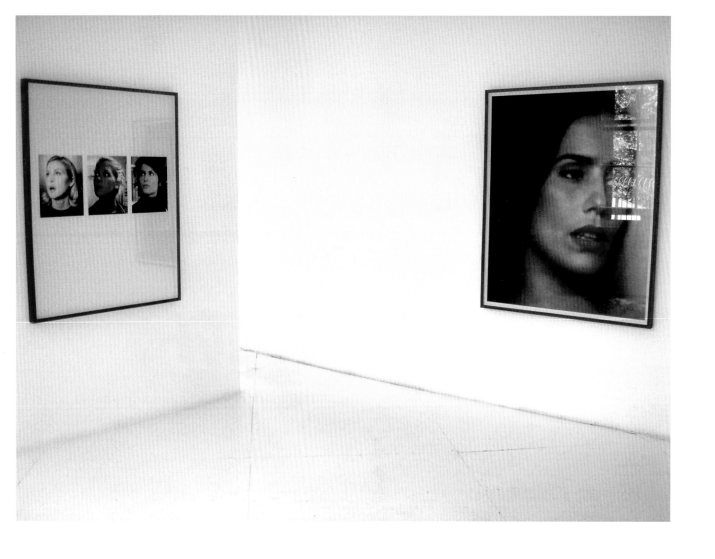

20. Julian Rosefeldt, 'New Works', MW Projects, 2004
21. Lucy Skaer, 'The Problem in Seven Parts', Counter Gallery, 2004

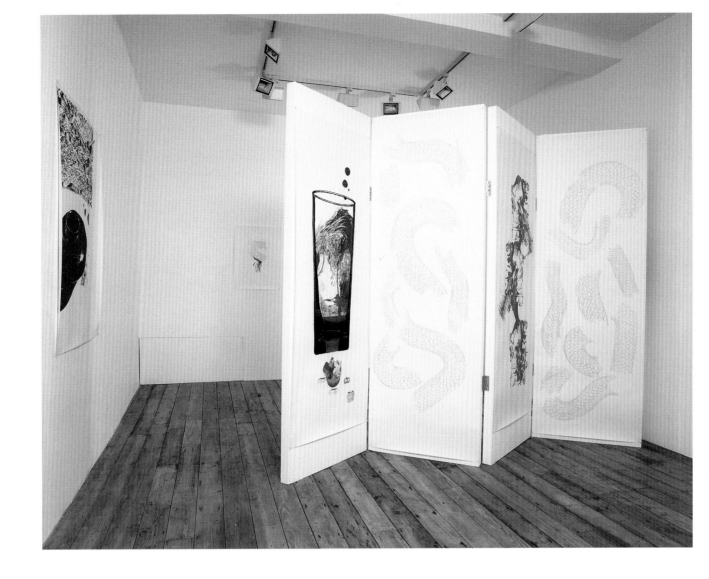

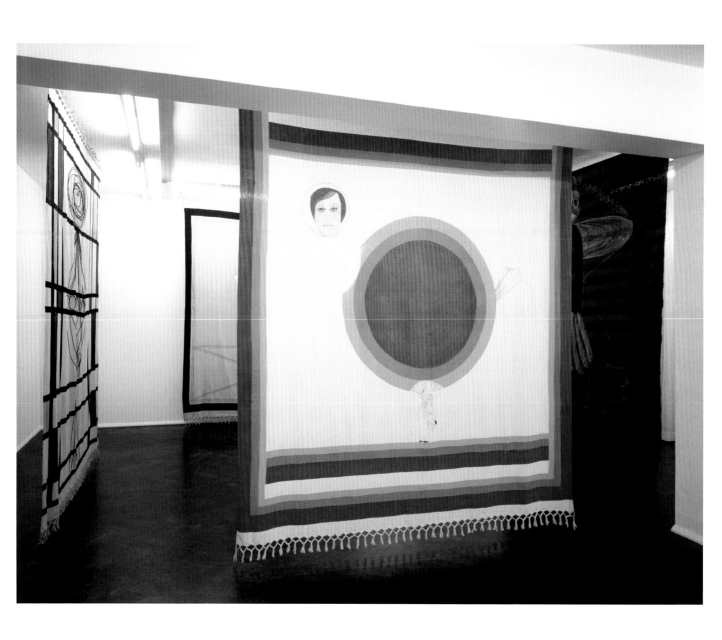

22. Enrico David, 'Wizard's Sleeve', Cabinet, 2005
23. Olafur Eliasson, *The Weather Project*,
Turbine Hall, Tate Modern, 2004

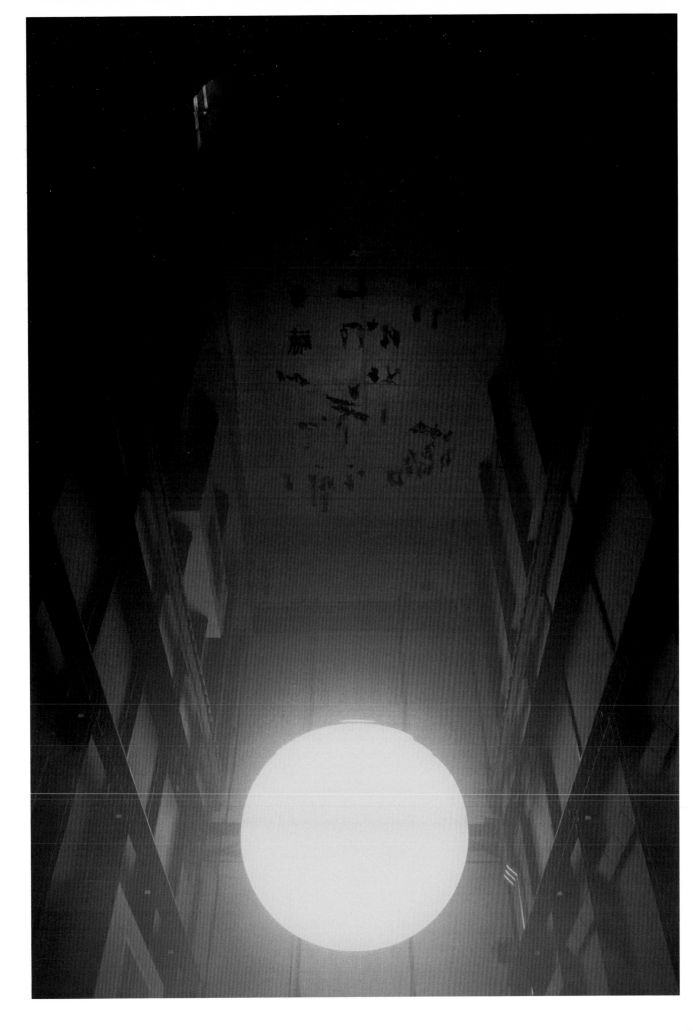

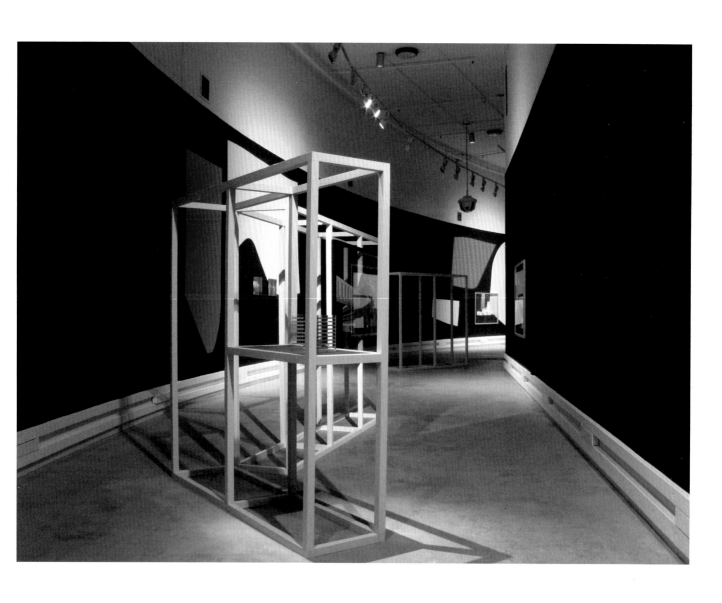

24. Toby Paterson, 'After the Rain',
The Curve, Barbican Art Gallery, 2005
25. Simon Popper, 'Alterity Display',
Lawrence O'Hana Gallery, 2004

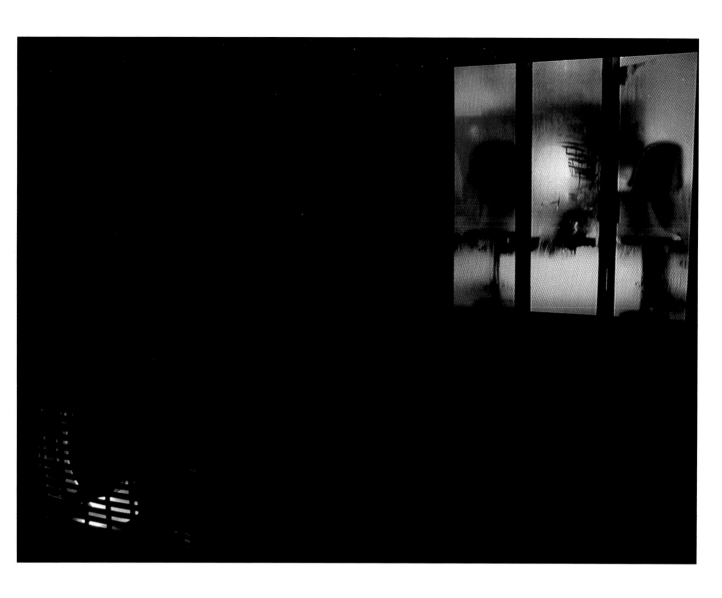

26. Till Exit, 'STRAND in several harmonies', i-cabin, 2005
27. Anri Sala, Hauser & Wirth London, 2004

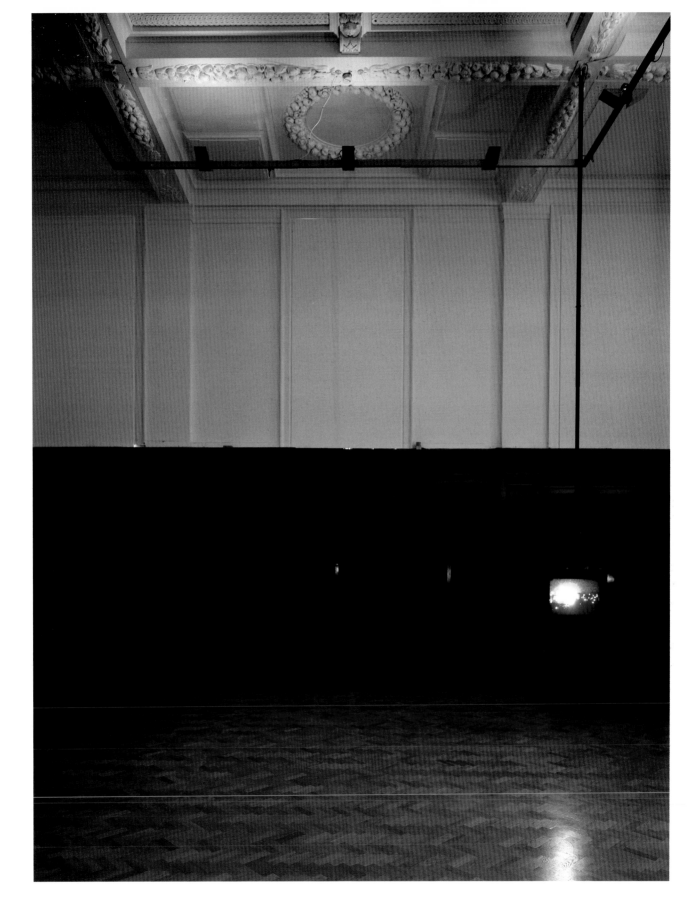

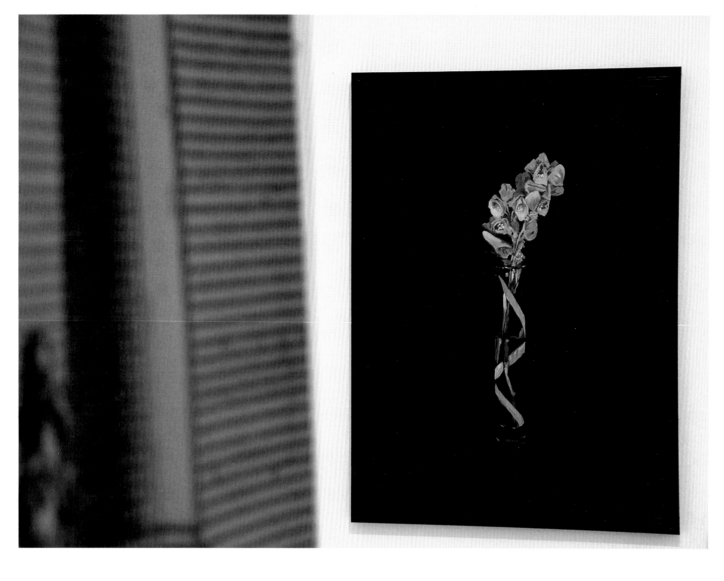

28. 'In the Palace at 4 am', Alison Jacques Gallery, 2004
29. Mark Leckey, *The Destructors*, Conway Hall,
8 July 2004, part of Infra Thin Projects

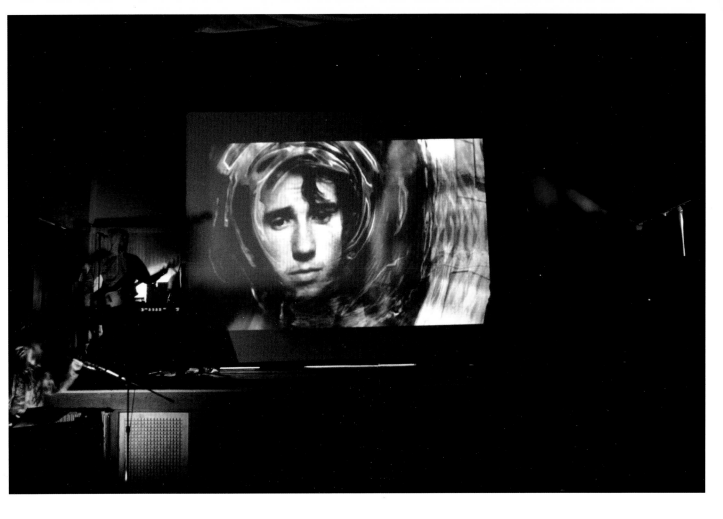

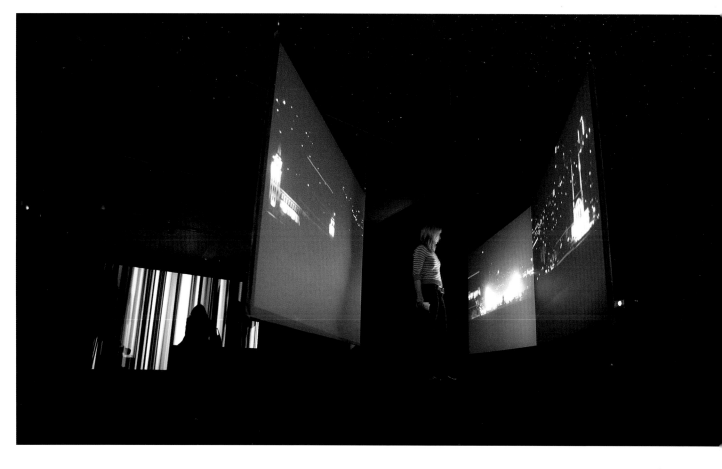

30. Beck's Futures 2004, ICA, 2004
31. David Thorpe, Art Now, Tate Britain, 2004

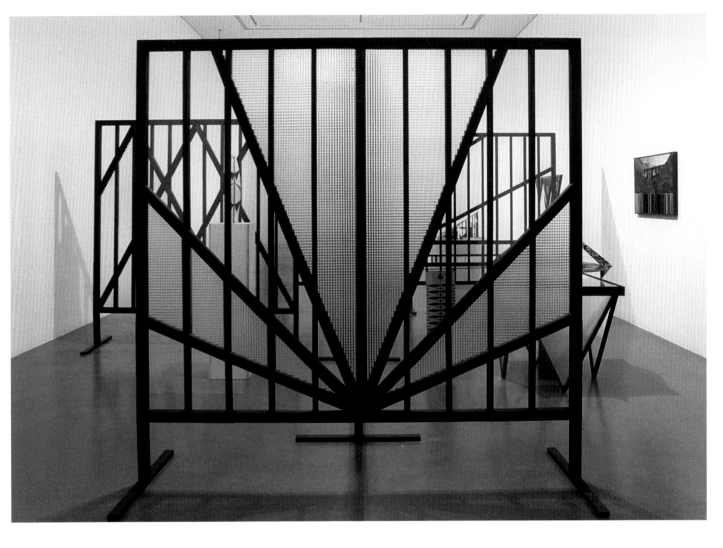

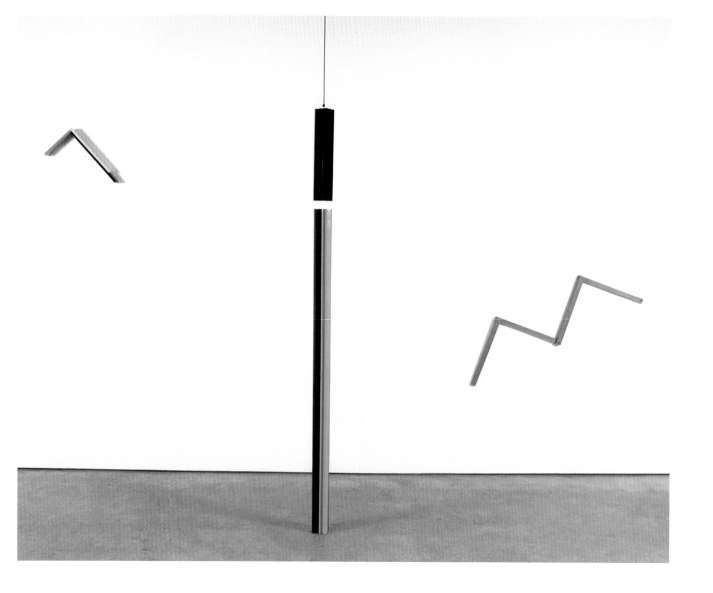

32. Camila Løw, Sutton Lane, 2004
33. Jason Martin, 'Day Paintings', Lisson Gallery, 2004

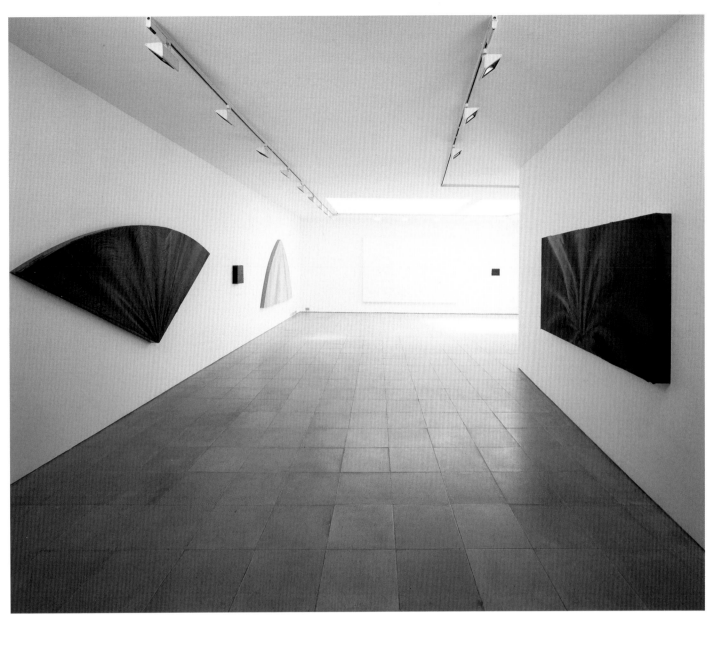

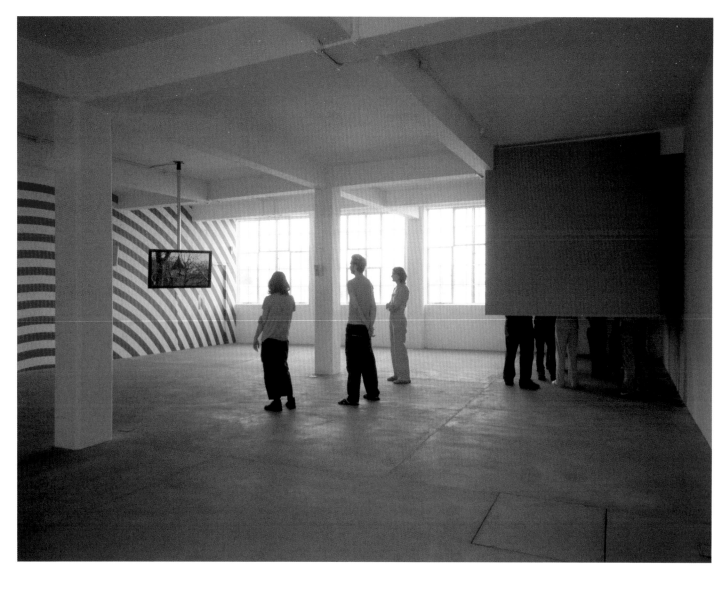

34. Lucy Gunning, 'Esc', Matt's Gallery, 2004
35. Sol LeWitt, 'New Work', Lisson Gallery, 2004

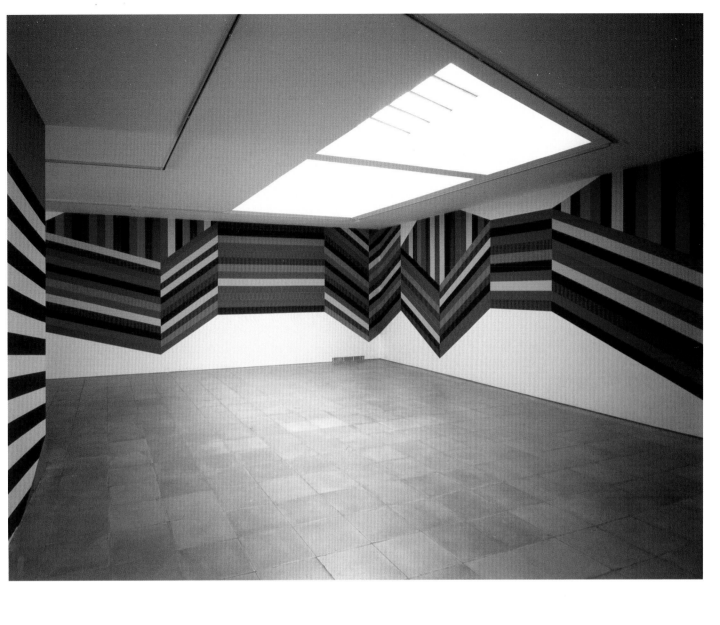

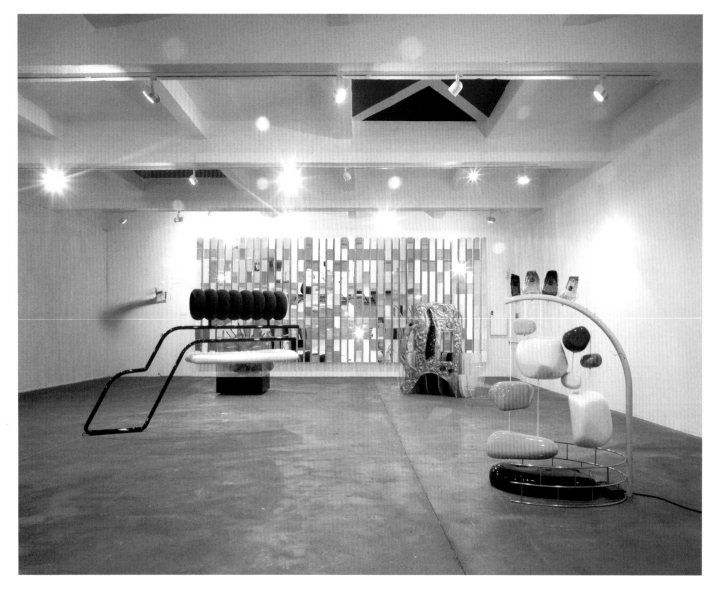

36. Gary Webb, 'Deep Heat T-Reg Laguna', Chisenhale Gallery, 2004
37. Isa Genzken, 'Wasserspeier and Angels', Hauser & Wirth London, 2004

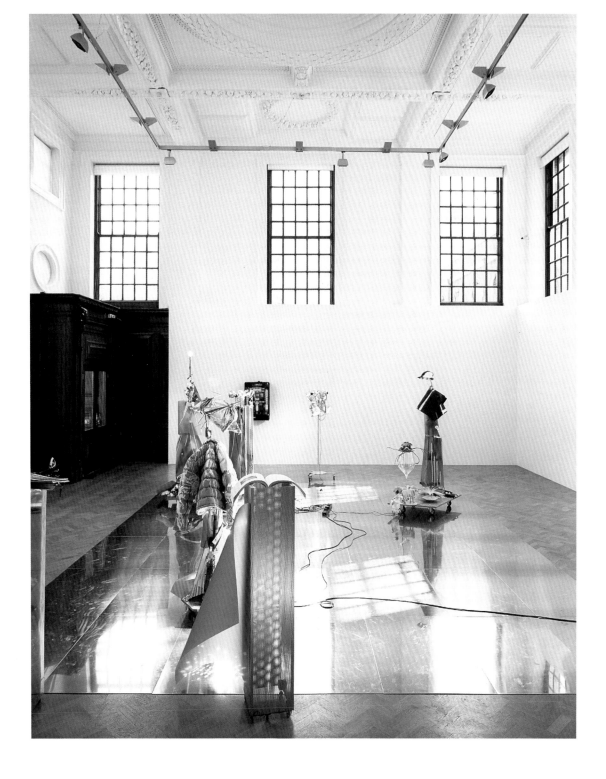

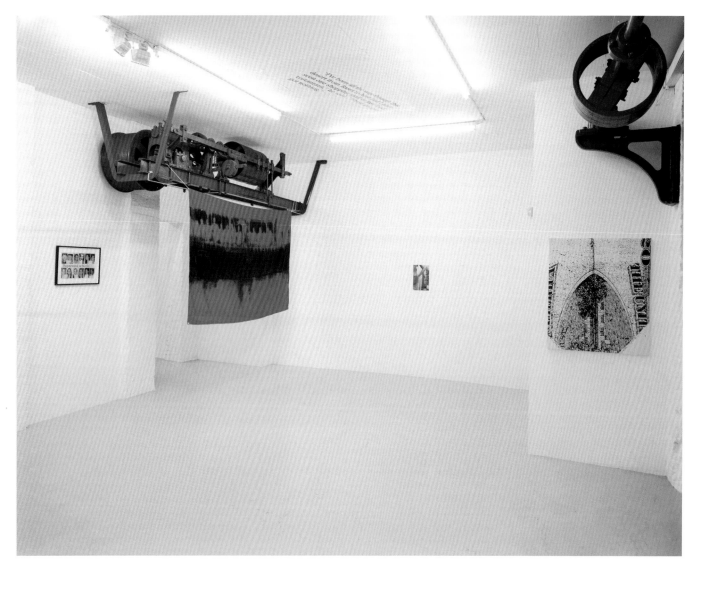

38. Nate Lowman, 'Re: Re: Re: produce', Ritter/Zamet, 2004
39. Keith Coventry, 'New Works', Kenny Schachter Rove, 2004

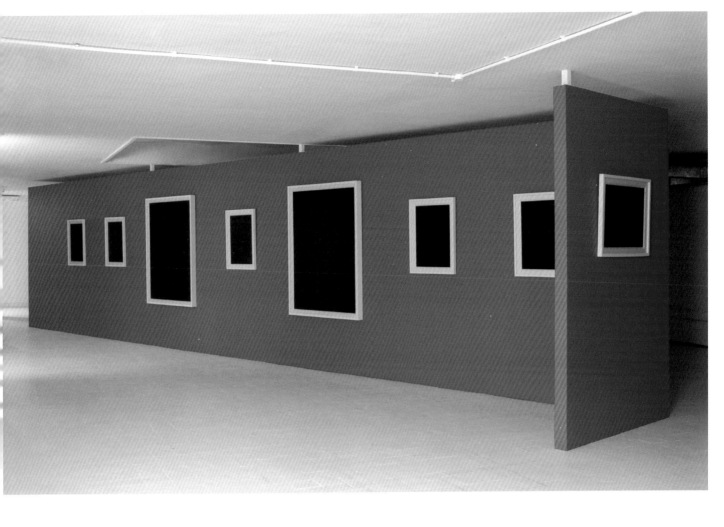

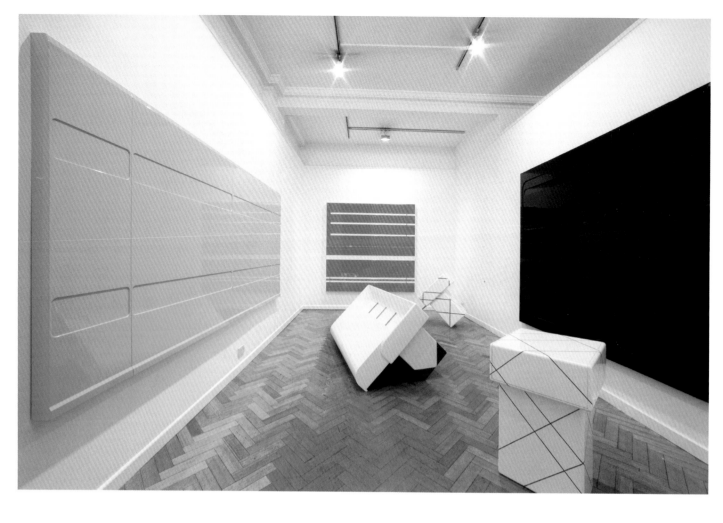

40. Lars Wolter, 'horizontals, verticals & vans', Rocket, 2004
41. Stefan Kürten, 'Say Hello, Wave Goodbye', Thomas Dane, 2005

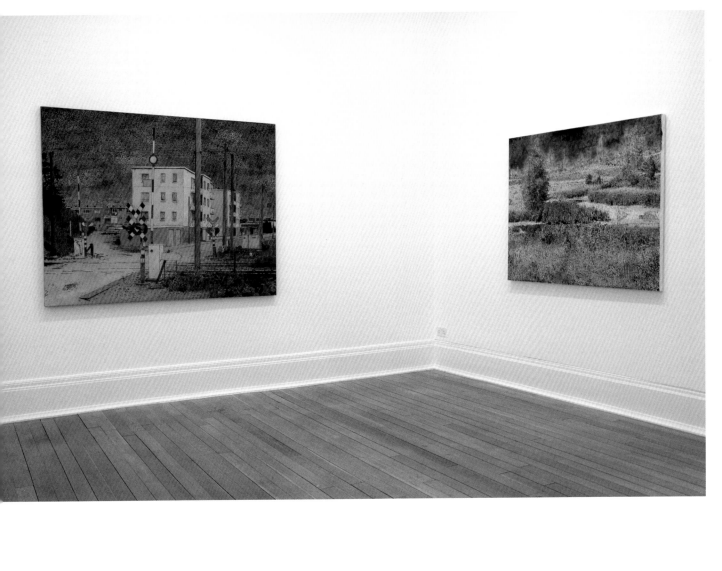

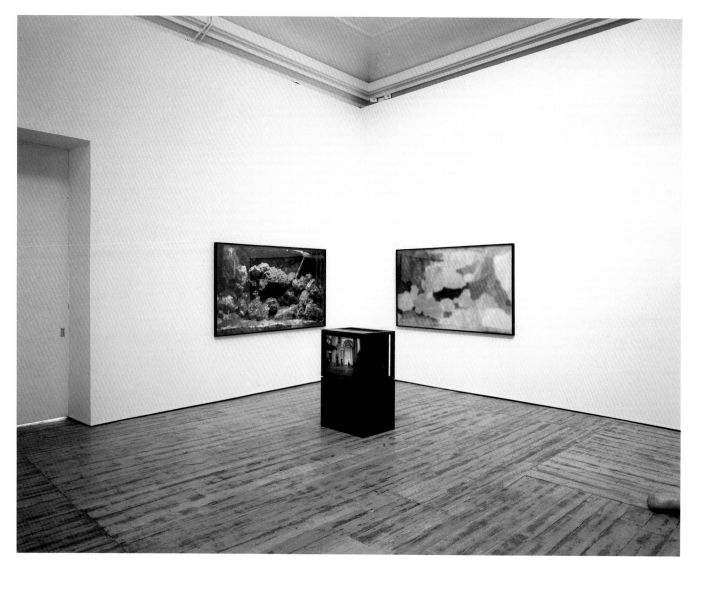

42. 'Animals', Haunch of Venison, 2004
43. Richard Hawkins, Corvi-Mora, 2004

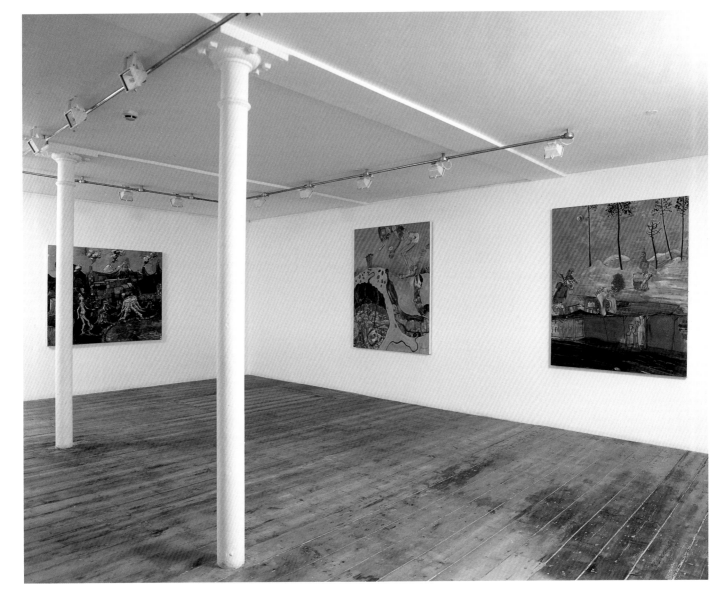

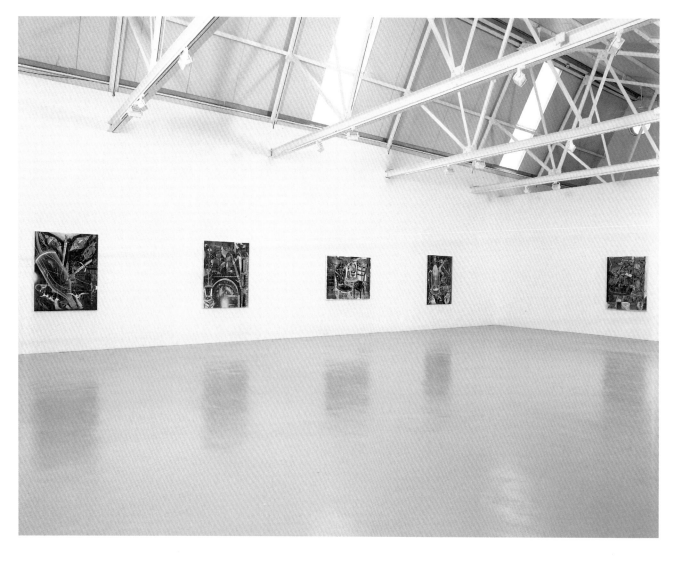

44. Lari Pittman, greengrassi, 2004
45. Cy Twombly, 'Ten Paintings and a Sculpture',
Gagosian Gallery, Britannia Street, 2004

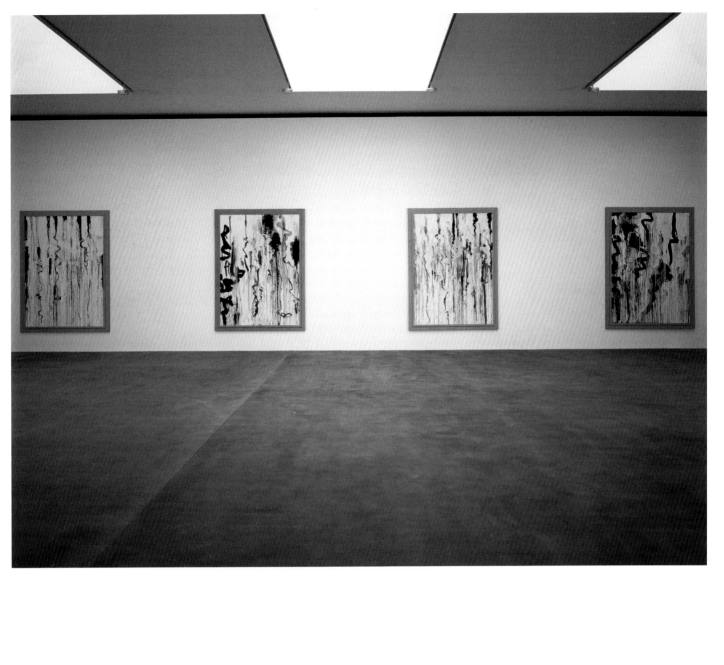

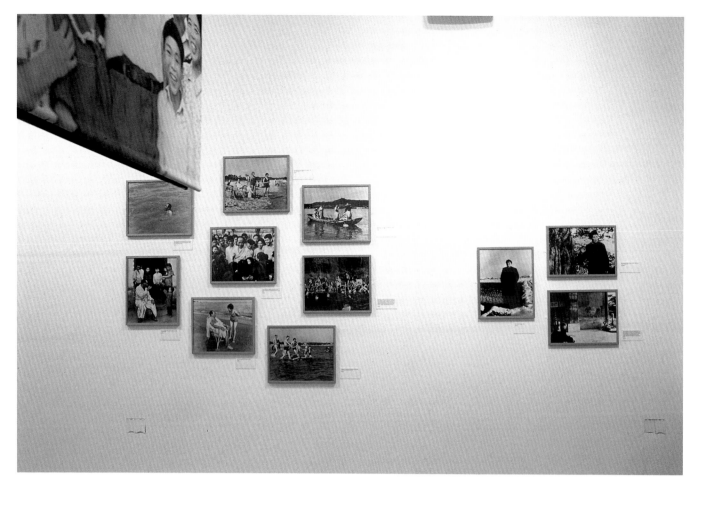

46. 'Hou Bo & Xu Xiaobing, Mao's Photographers',
The Photographers' Gallery, 2004
47. Jason Meadows, Corvi-Mora, 2004

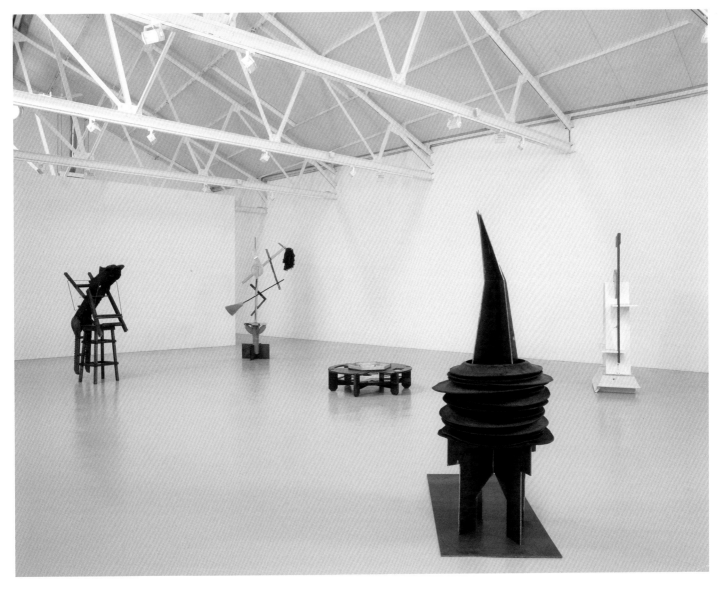

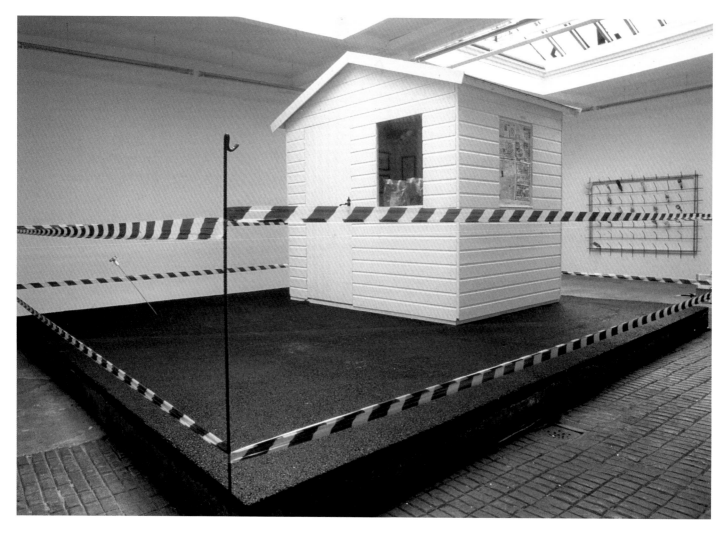

48. Klaus Weber, 'Unfolding Cul-de-Sac' Cubitt, 2004
49. Tony Smith, 'Wall', Timothy Taylor Gallery, 2004

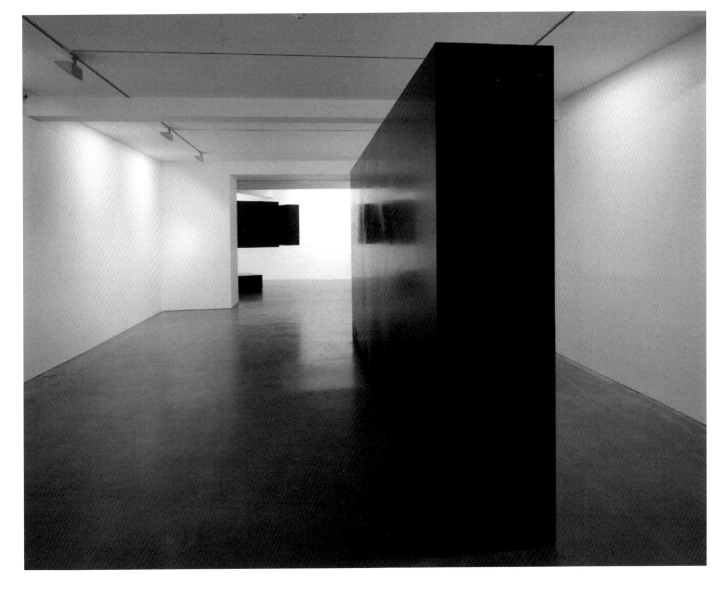

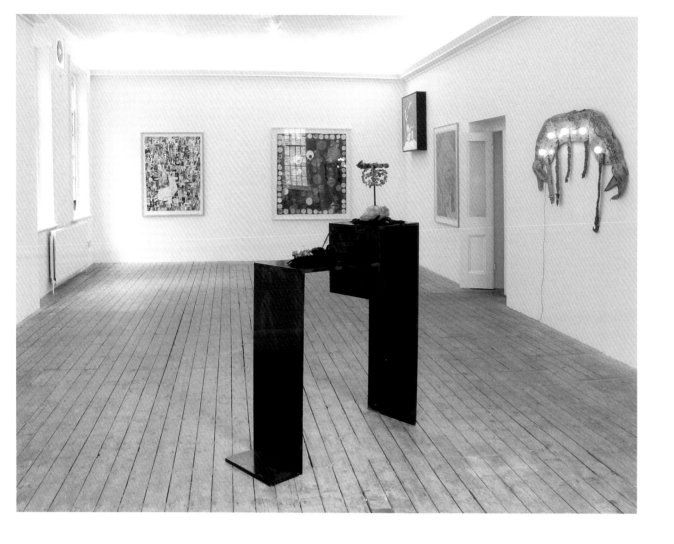

50. 'Her Kind', The Approach, 2004
51. 'Meet You At The Corner', FORTESCUE AVENUE /
Jonathan Viner, 2005

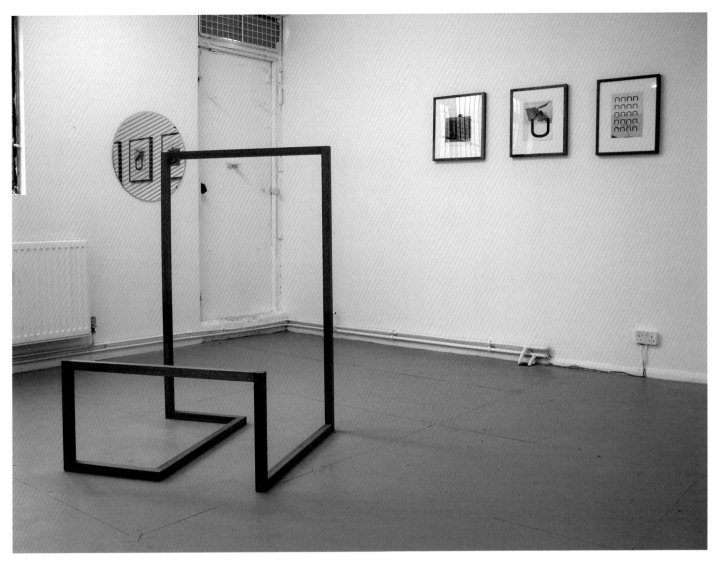

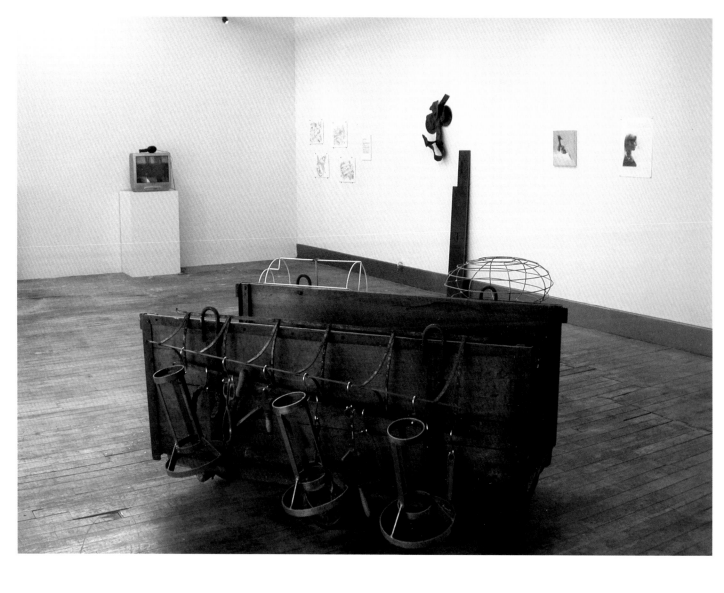

52. 'Trailer', Man in the Holocene, 2004
53. 'TOTEM', MOT, 2004

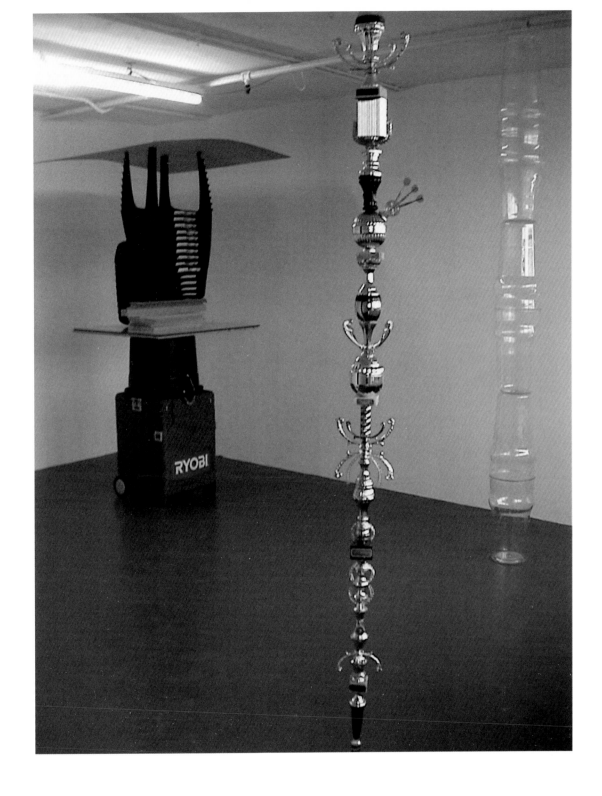

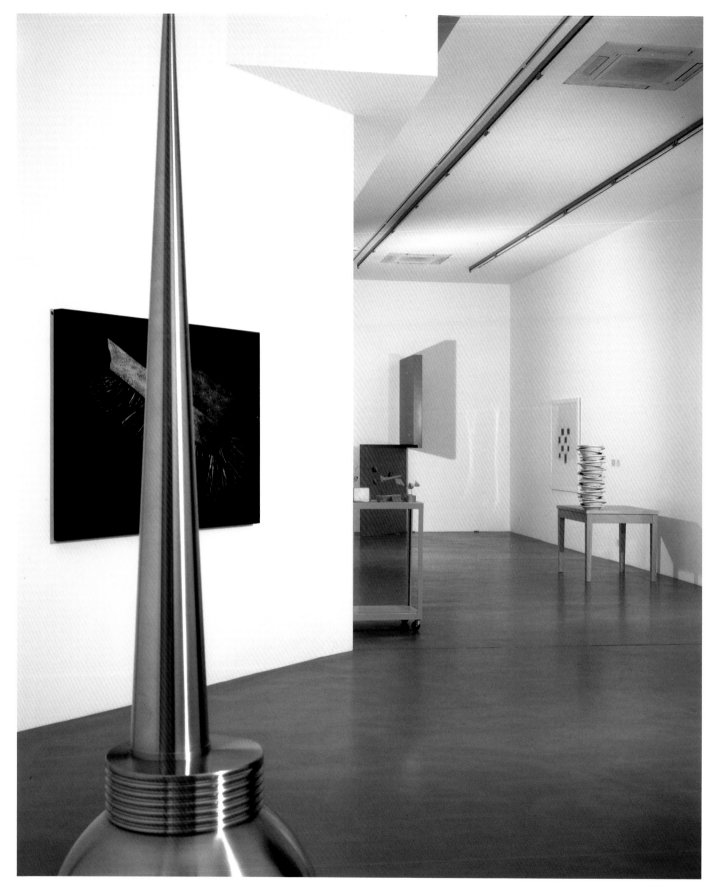

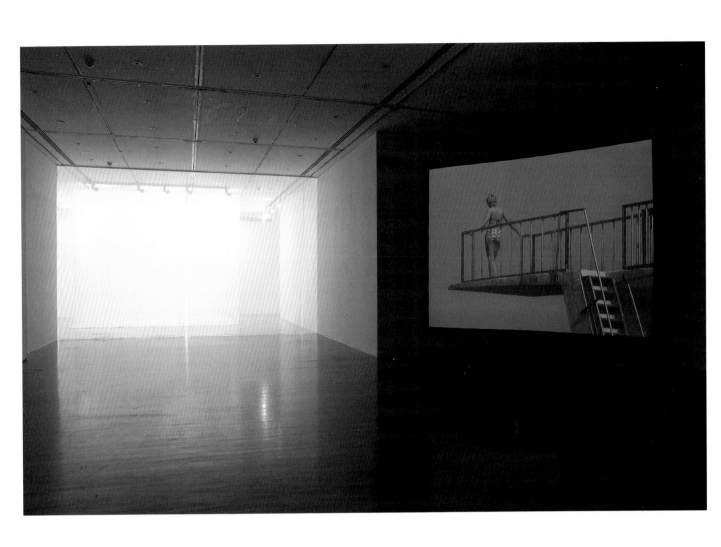

54. Robert Therrien, Sprüth Magers Lee, 2004
55. 'Do Not Interrupt Your Activities', organised by
MA Curating Contemporary Art, Royal College of Art, 2005

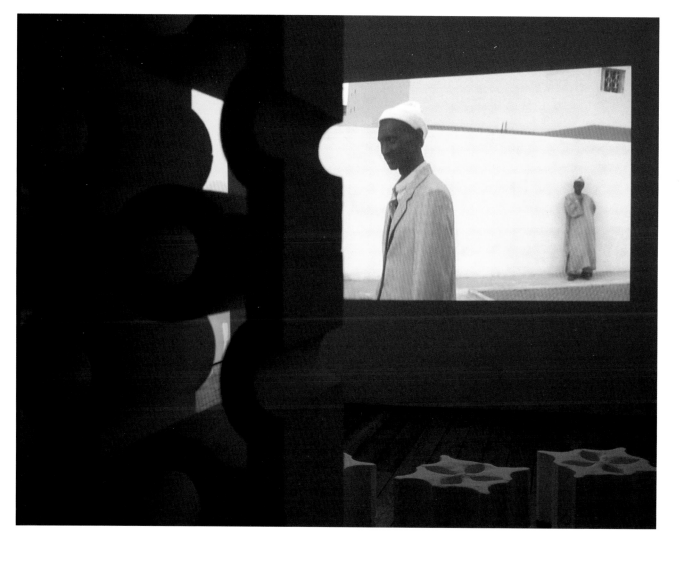

56. Mark Aerial Waller, 'SUPERPOWER – DAKAR CHAPTER',
Counter Gallery, 2004
57. James Turrell, Albion, 2004

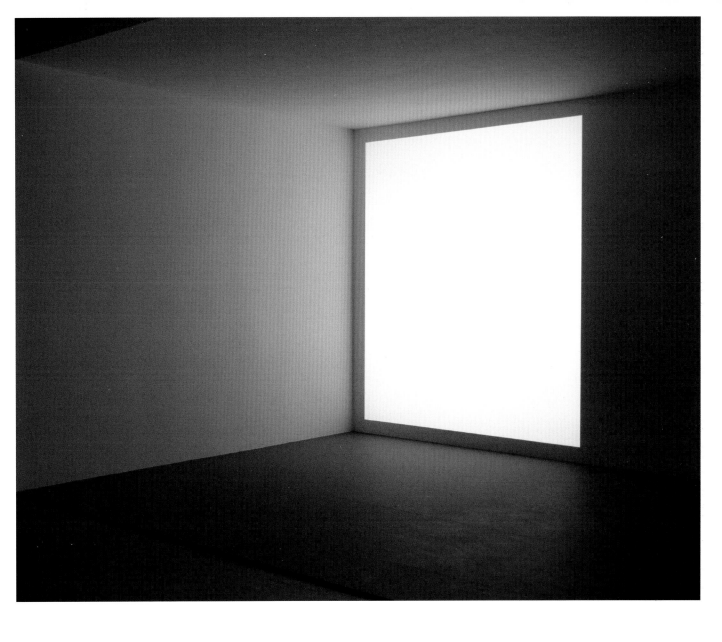

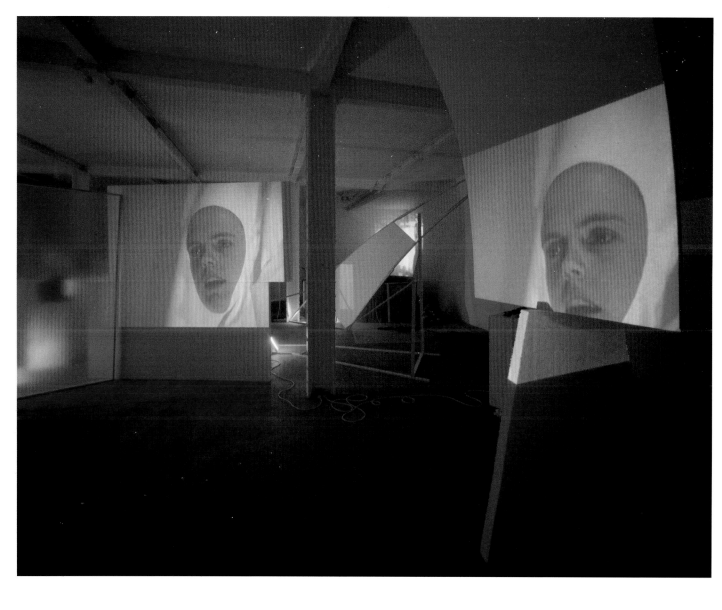

58. Nathaniel Mellors, 'Profondo Viola', Matt's Gallery, 2004
59. 'This Much is Certain', organised by
MA Curating Contemporary Art, Royal College of Art, 2004

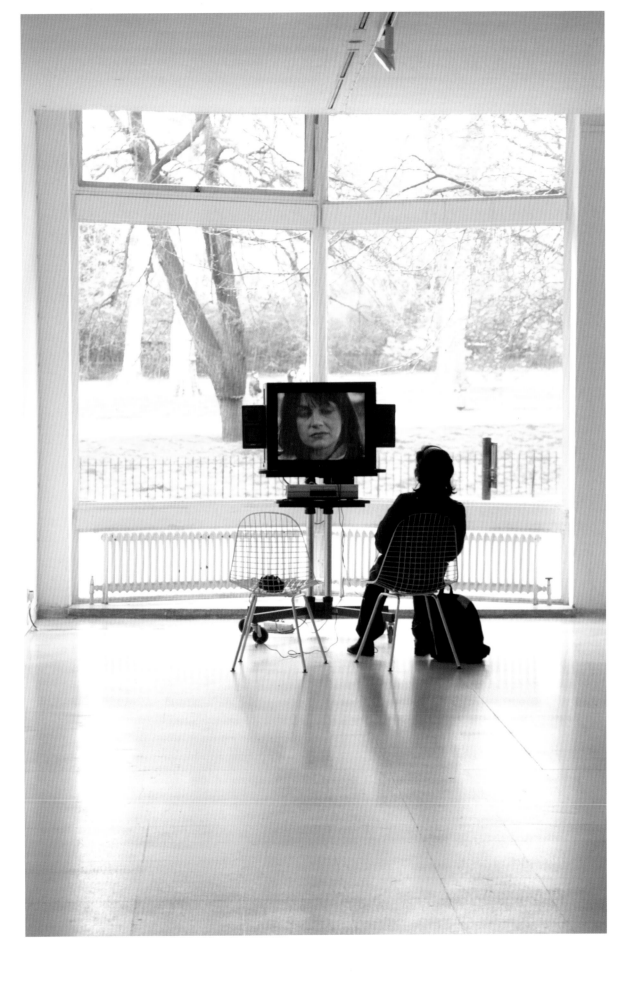

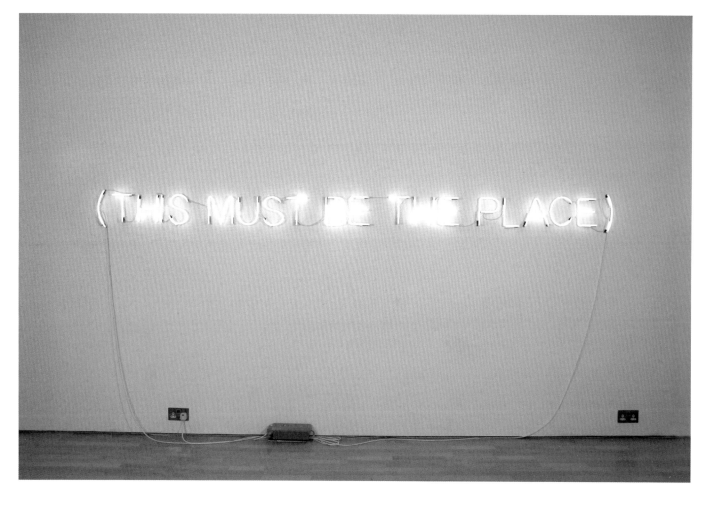

60. Stefan Brüggemann, 'Five Text Pieces',
Blow de la Barra, 2005
61. Martin Creed, Hauser & Wirth London, 2004

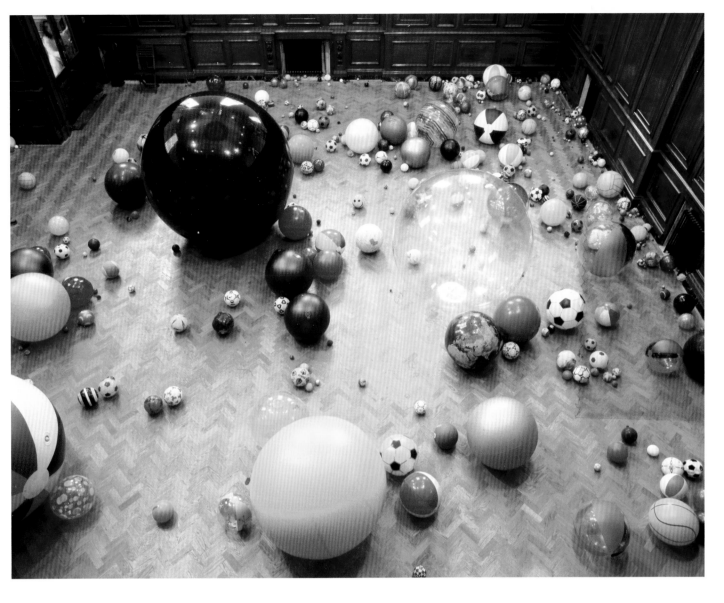

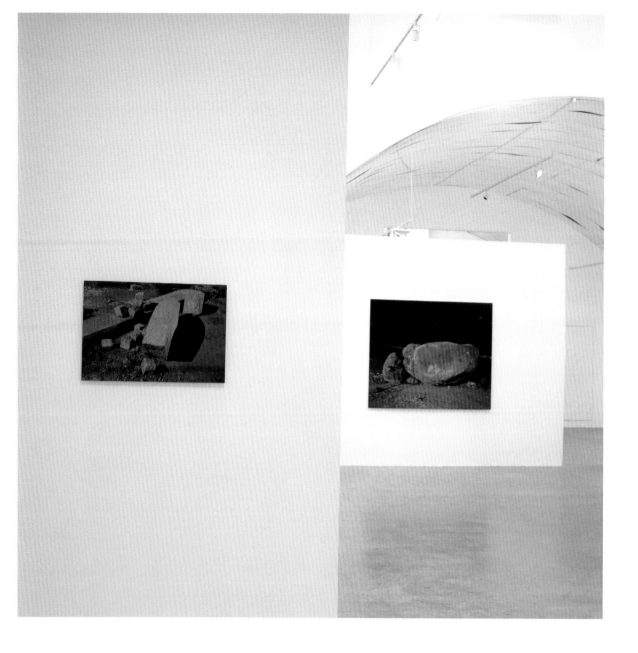

62. Rut Blees Luxemburg, 'To Delphi', Union Gallery, 2004
63. Christoph Ruckhäberle, Sutton Lane, 2004

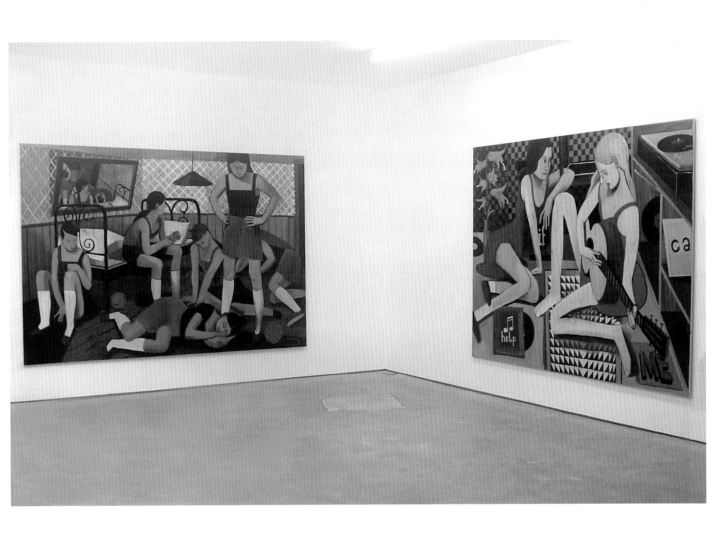

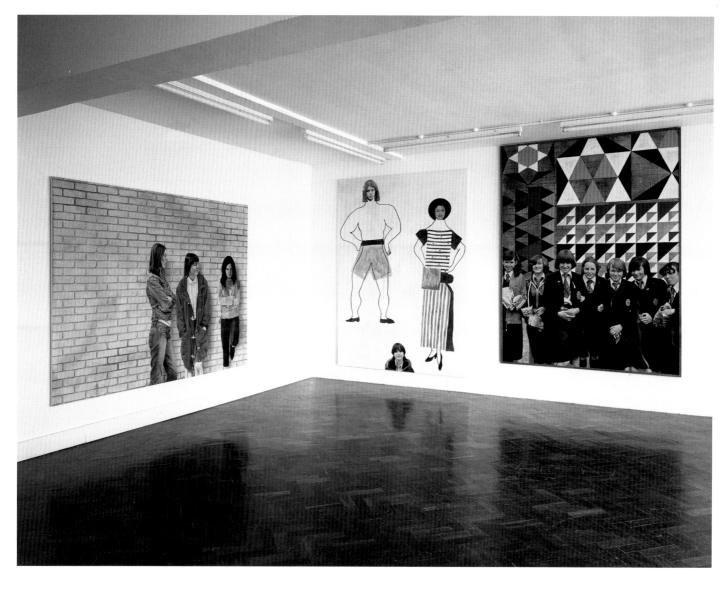

64. Lucy McKenzie, 'Bi-Curious', Cabinet, 2004
65. Los Super Elegantes & assume vivid astro focus,
Make It With You: A Slow Dance Club, Frieze Art Fair 2004

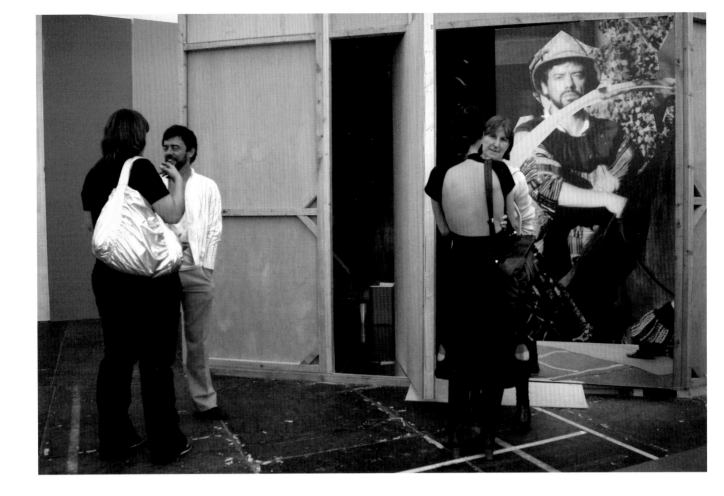

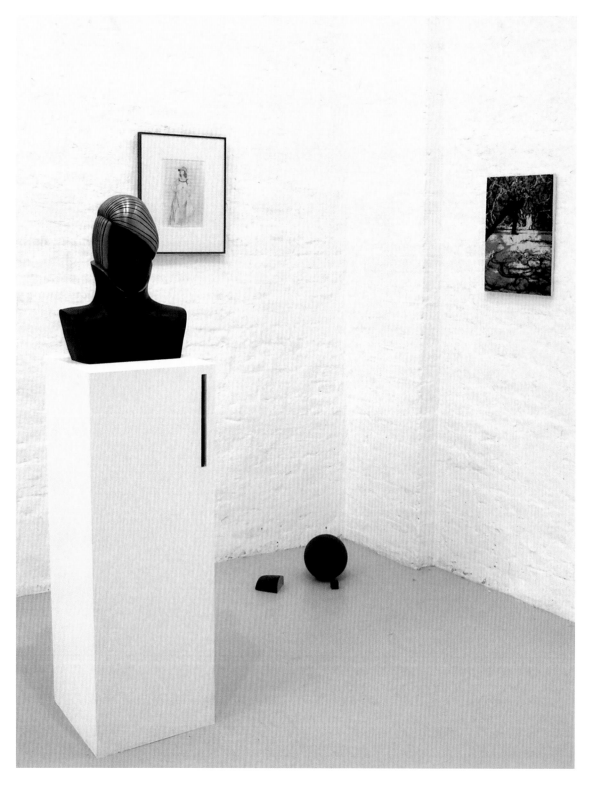

66. 'XS – An Invitational Exhibition',
f a projects, 2005
67. Henrik Plenge Jakobsen, 'J'Accuse',
South London Gallery, 2005

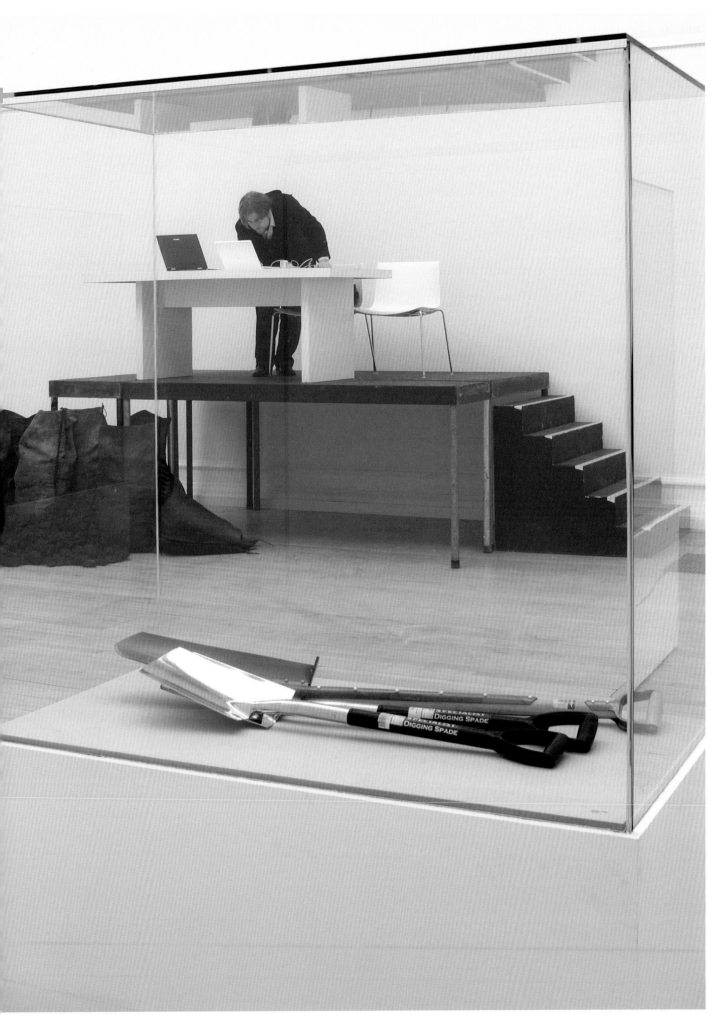

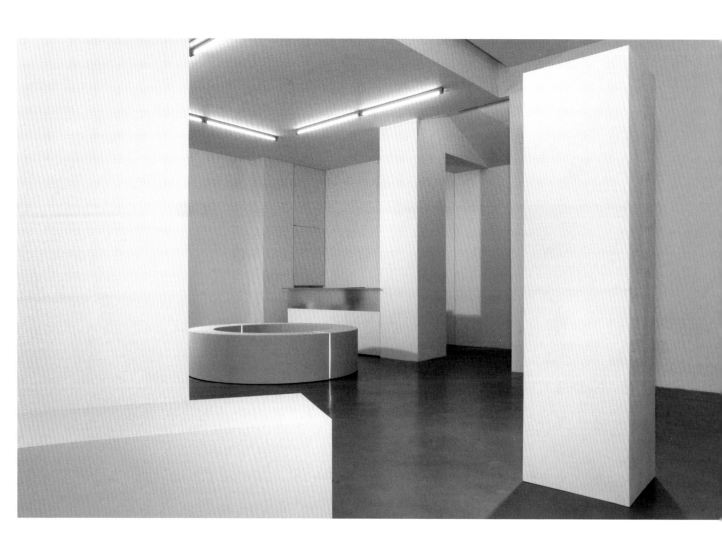

68. Robert Morris, 'Early Sculpture',
Sprüth Magers Lee, 2005
69. Jimmy Robert and Ian White,
6 things we couldn't do, but can do now,
Art Now, Tate Britain, 20 November 2004

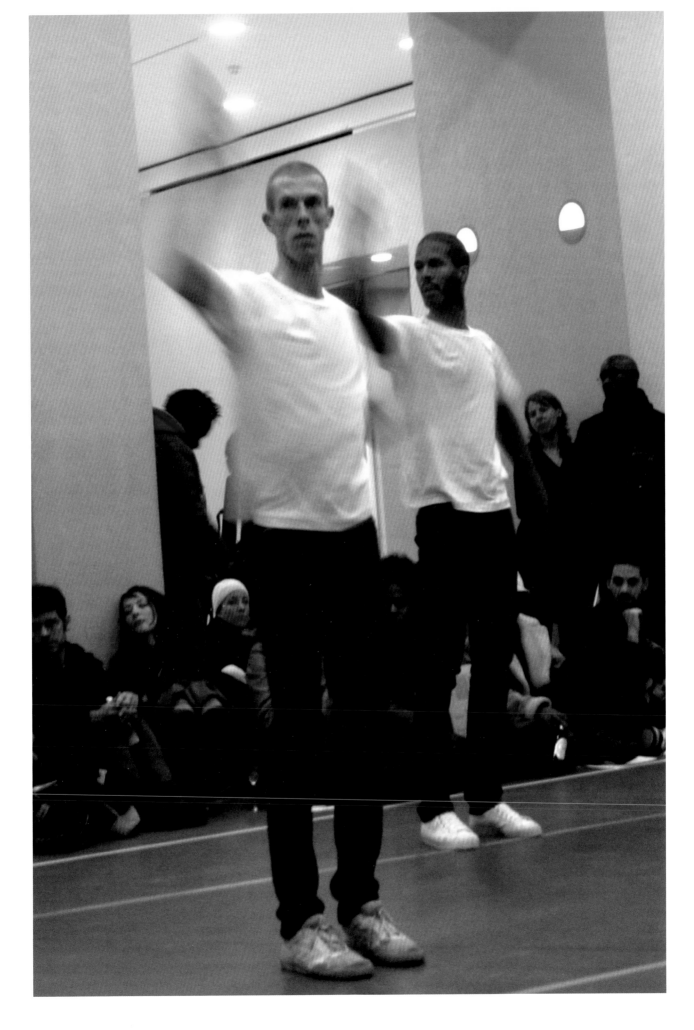

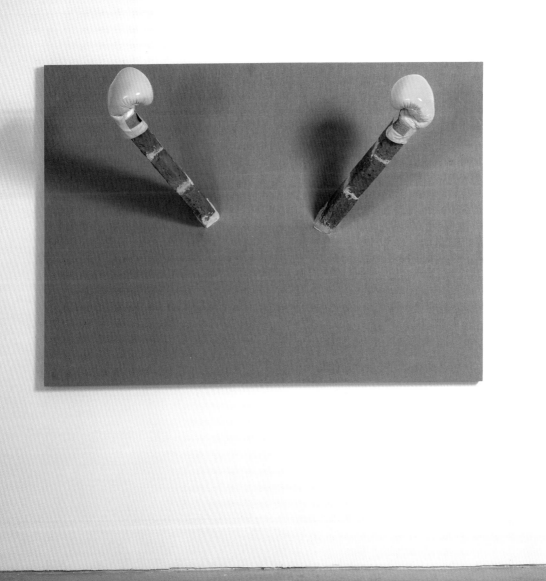

70. Georg Herold, 'Bollinger War's',
Anthony Reynolds Gallery, 2004
71. Giles Round, *Monument*, 'Alterity Display',
Lawrence O'Hana Gallery, 2004

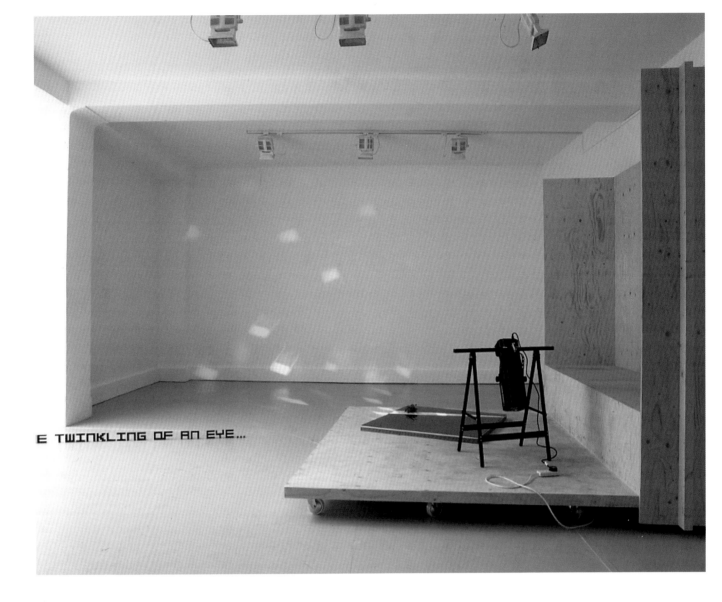

E TWINKLING OF AN EYE...

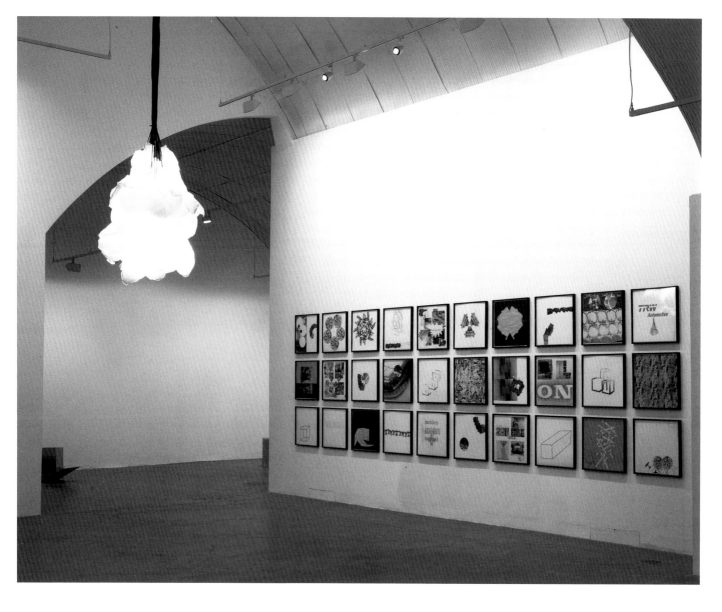

72. Jeppe Hein and Johannes Wohnseifer,
'Connected Presence', Union Gallery, 2004
73. David Hurn, Dae Hun Kwon, Rachmaninoff's, 2005

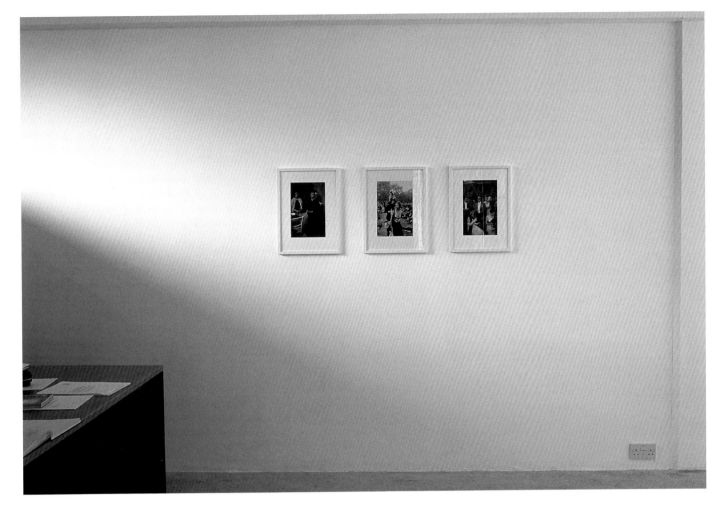

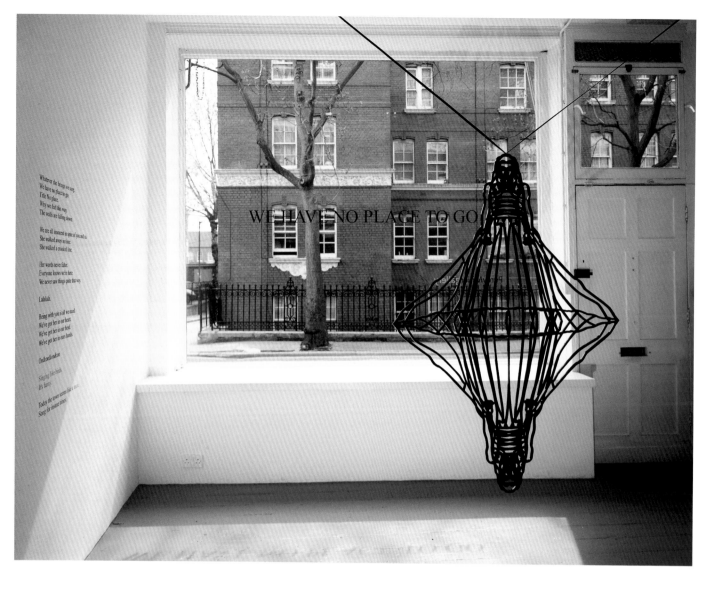

74. Corinne Sentou, 'We Have No Place To Go',
Percy Miller Gallery, 2004
75. Jorge Pardo, Haunch of Venison, 2004

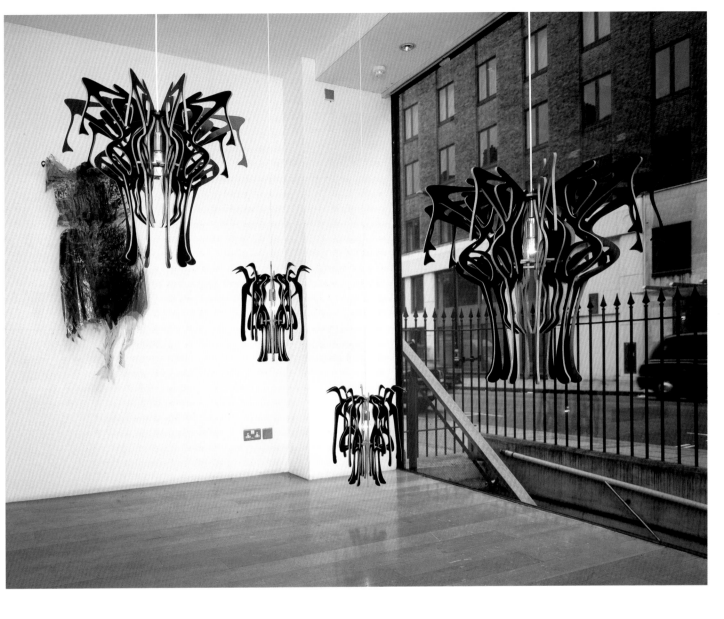

76. Carey Young, 'Disclaimer', IBID Projects, 2005
77. Paul Pfeiffer, Thomas Dane, 2004

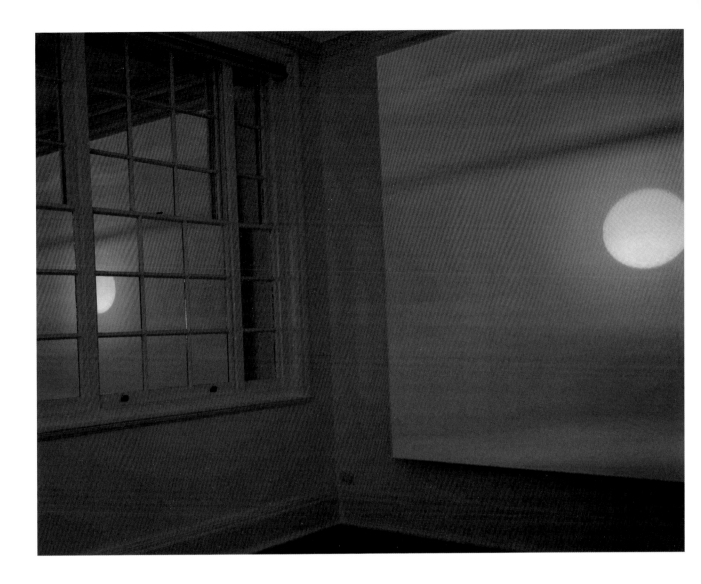

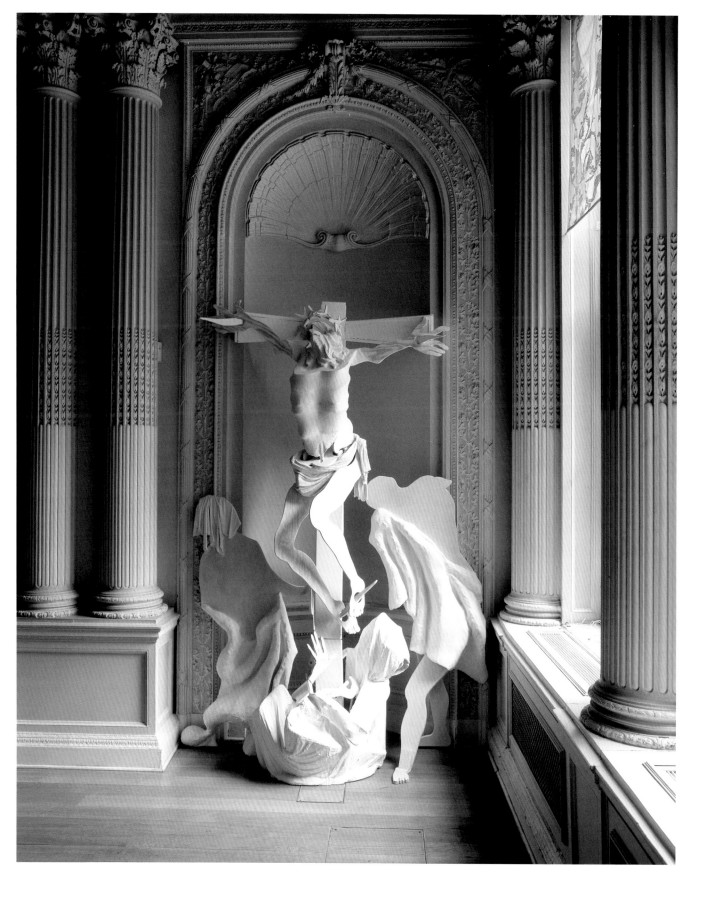

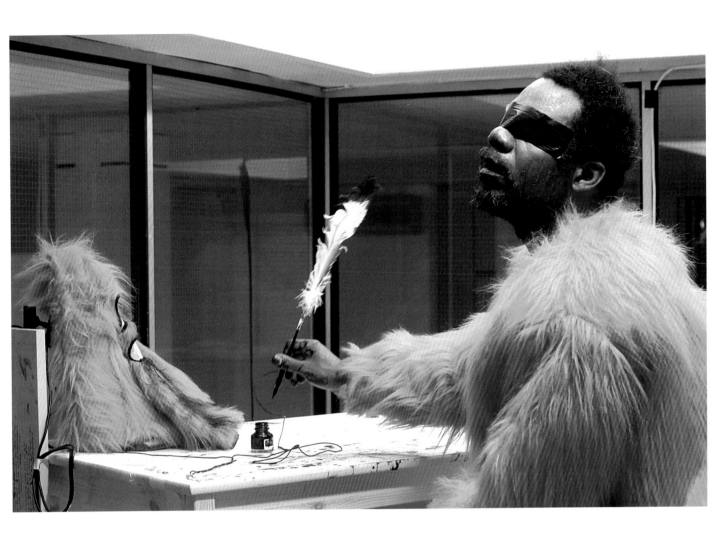

78. 'Frank Cohen collection', exhibited at 3 Grafton Street
during Art Fortnight London, 2004
79. William Pope.L, 'some things you can do with blackness...',
Kenny Schachter Rove, 2005

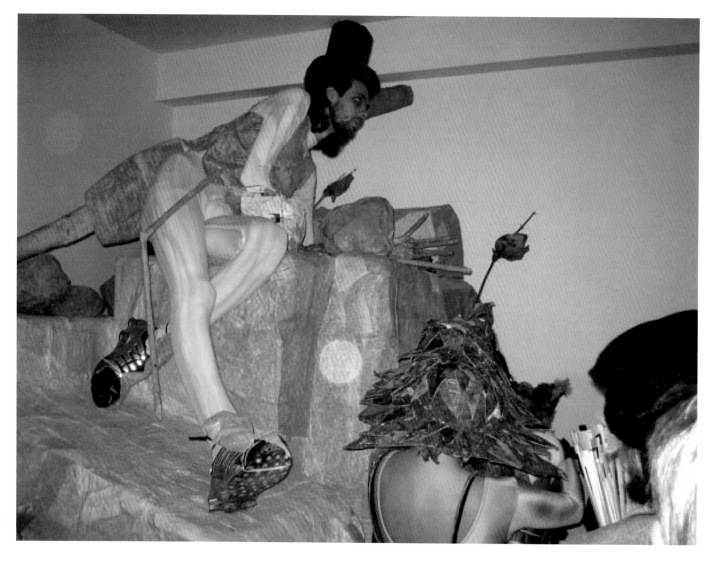

80. Lali Chetwynd, *Born Free*, Gasworks, 4 November 2004
81. 'Expander', Royal Academy of Arts
at 6 Burlington Gardens, 2004

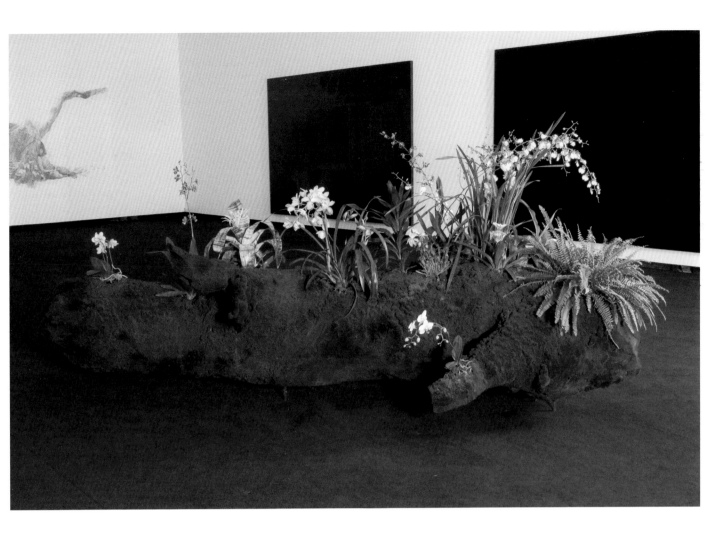

82. Heather and Ivan Morison 'are confused…',
Danielle Arnaud contemporary art, 2004
83. Pae White, *Rover Momentum*, Frieze Art Fair 2004

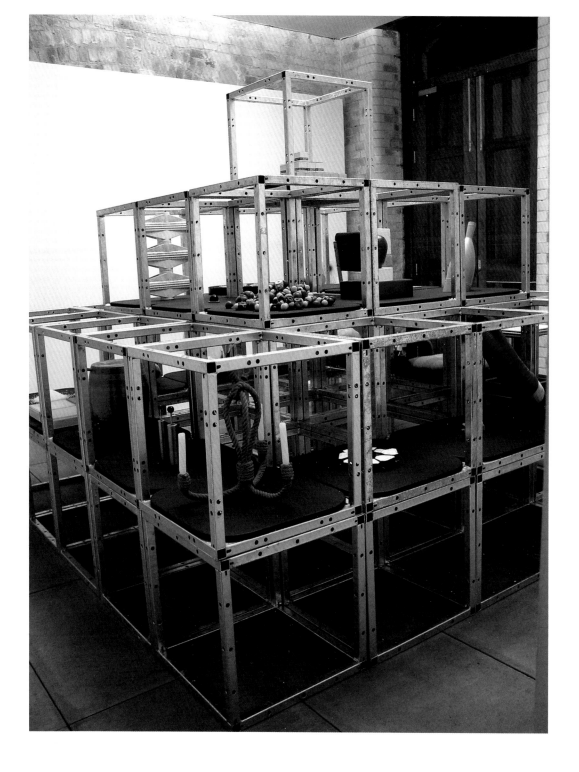

84. Keith Wilson, 'z is for ziggurat', One in the Other, 2003
85. Pablo León de la Barra, *Public Library*,
part of 'Publish and Be Damned', Cubitt, 2004

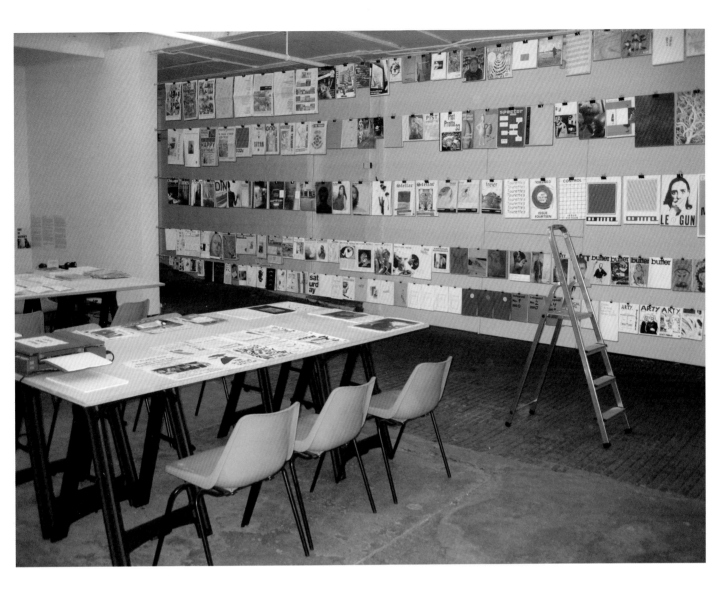

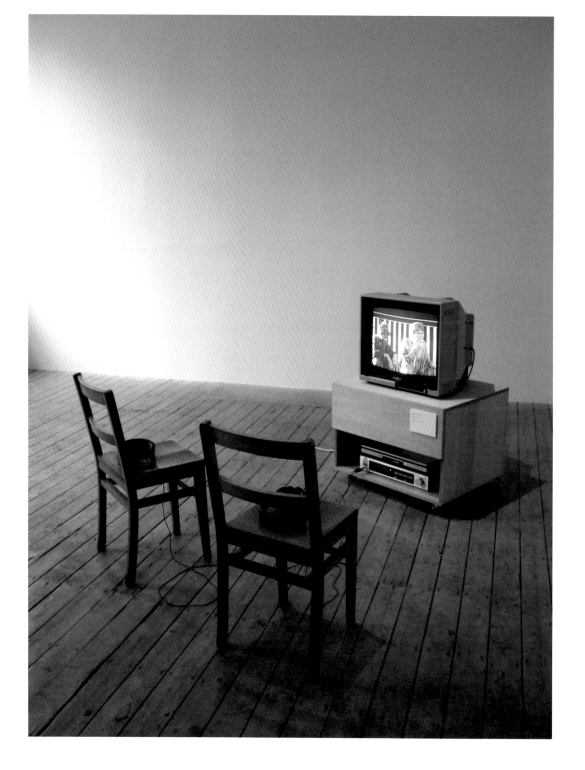

86. Inventory, 're:presentations of everyday life',
The Approach, 2004
87. Adam Chodzko, *Night Shift* (from *Design for a Carnival*),
Frieze Art Fair 2004

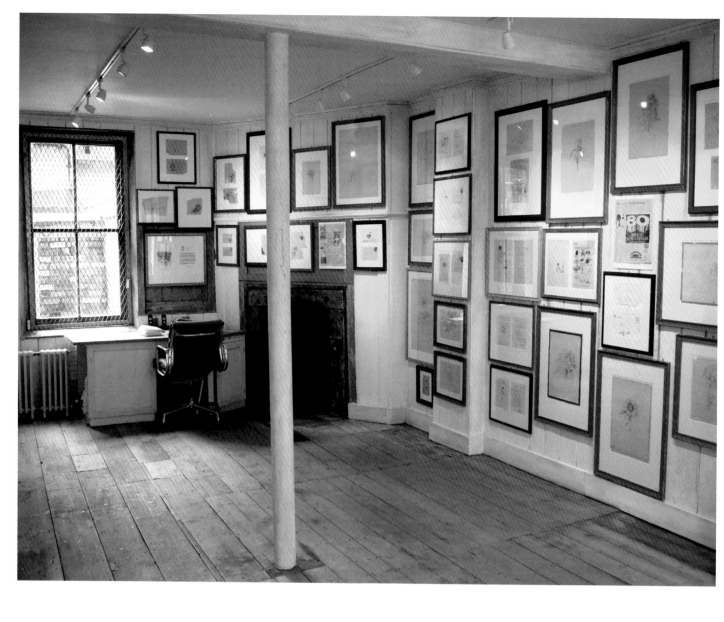

88. Naomi V Jelish, curated by John Ivesmail,
presented by Jamie Shovlin, Riflemaker, 2004
89. '100 Artists See God', ICA, 2005

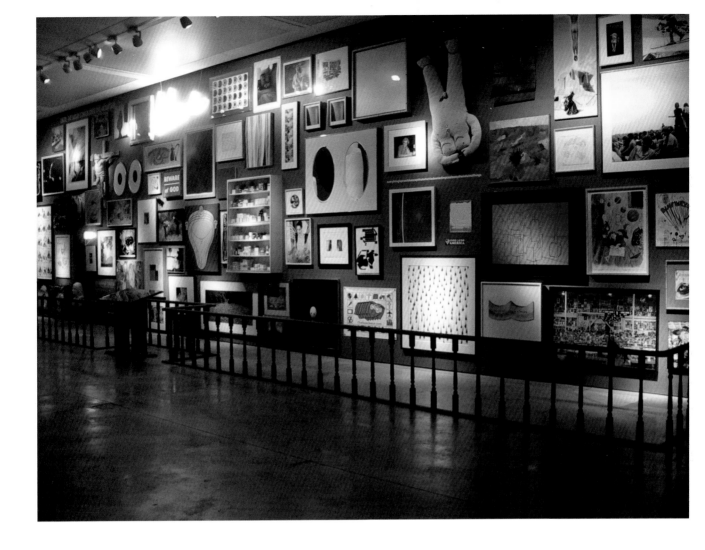

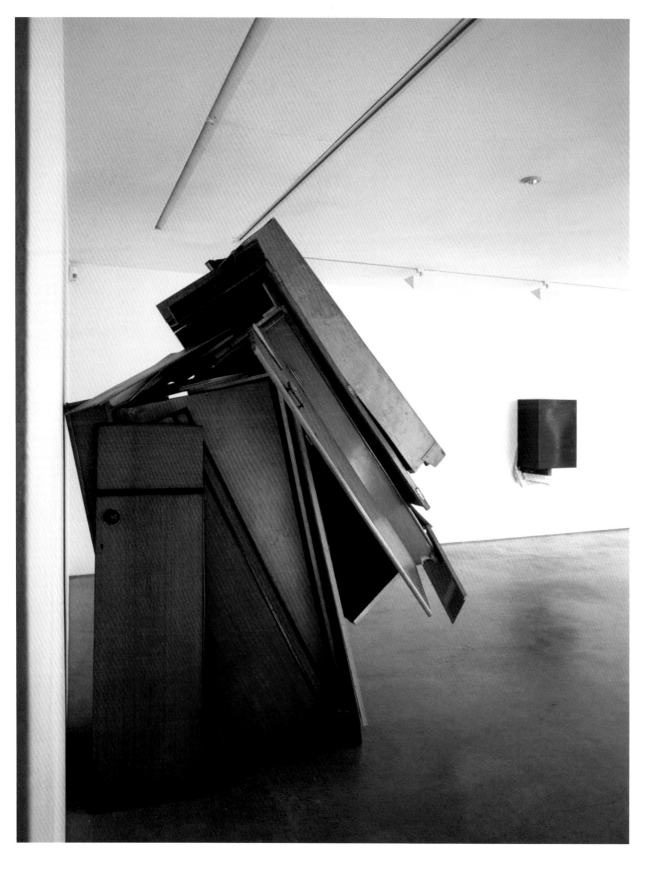

90. Ángela de la Cruz, Lisson Gallery, 2004
91. Gregor Schneider, *Die Familie Schneider*,
undisclosed location in the East End, Artangel, 2004

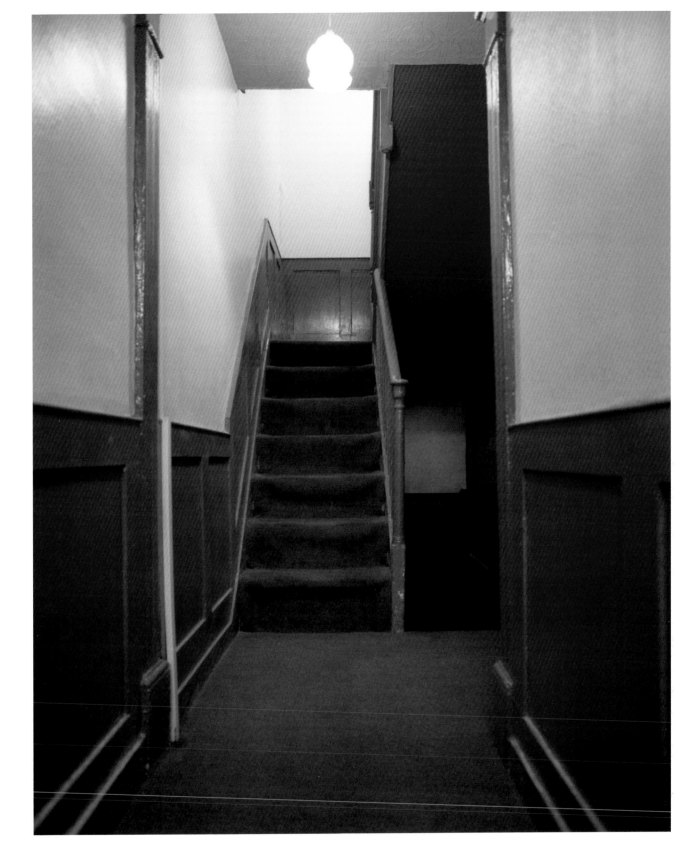

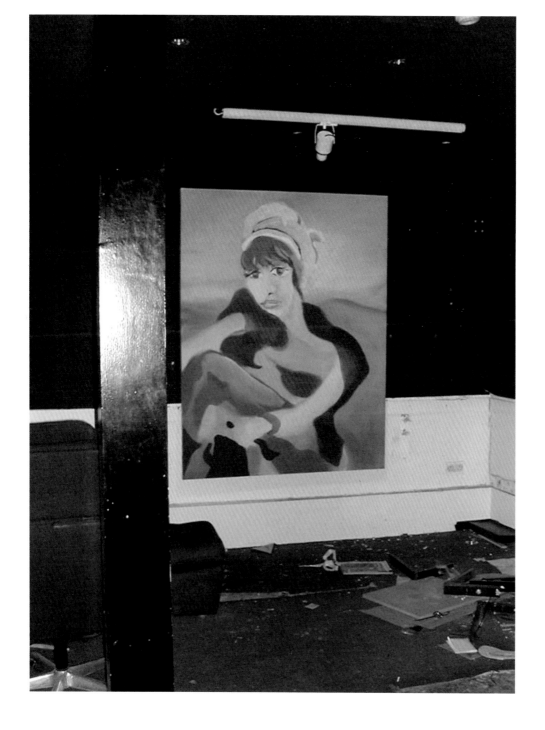

92. Sophie von Hellermann, 'On the Ground',
Vilma Gold, 2004
93. 'Concert in the Egg', The Ship, 2004

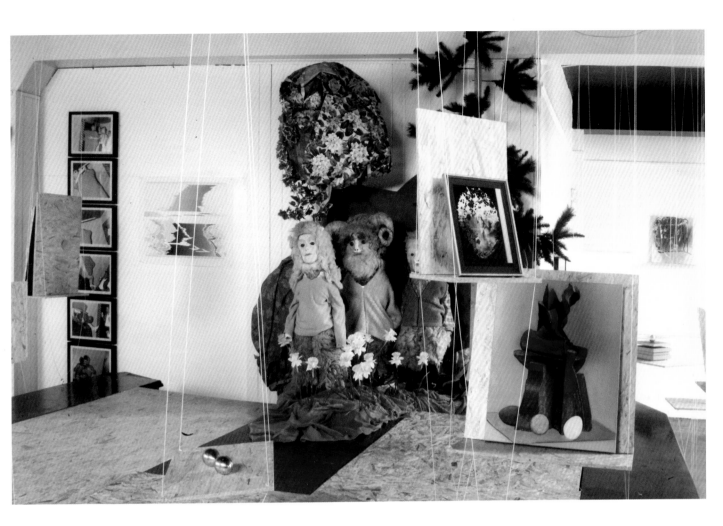

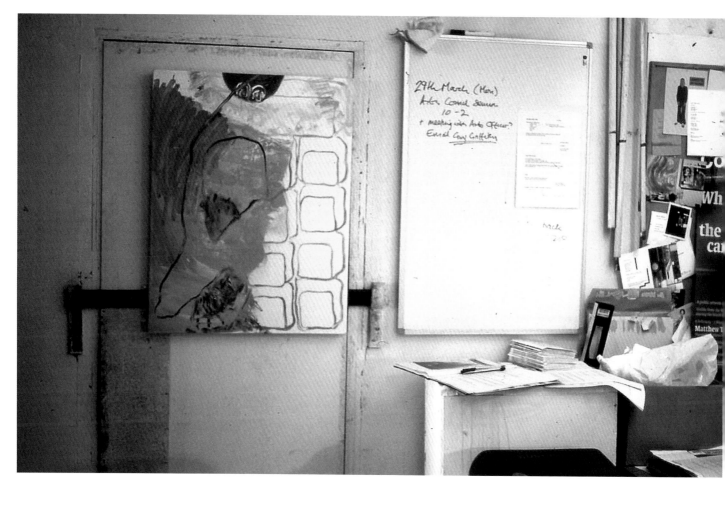

94. Luke Gottelier, 'Early Paintings',
week 3 of 'Quarters', Whitechapel Project Space, 2004
95. Deborah Castillo, 'South American Cleaner',
White Cubicle – 24/7 Toilet Gallery,
The George and Dragon, 2005

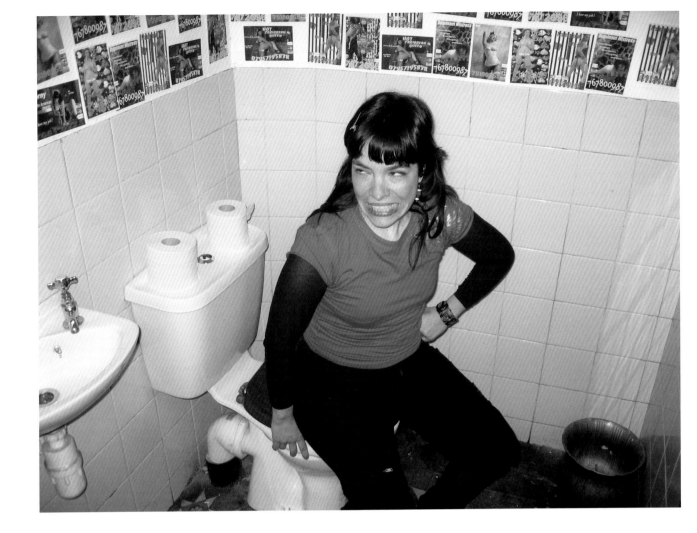

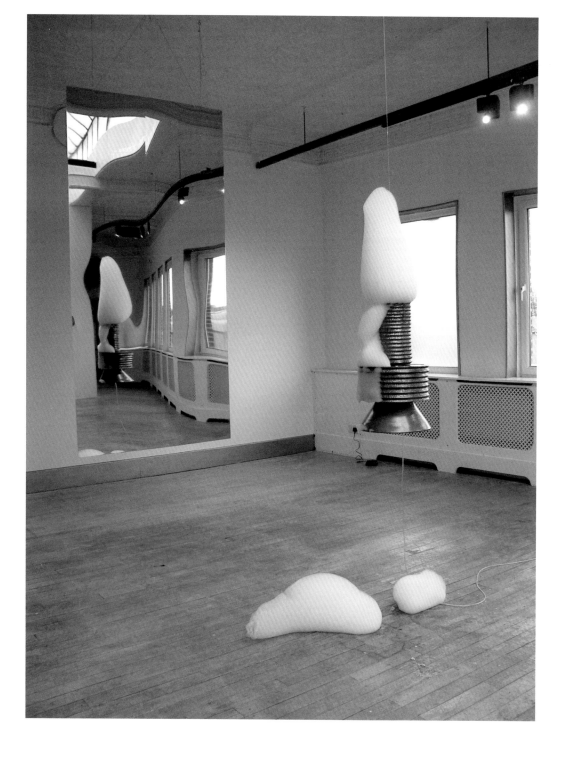

96. 'Fee of Angels', Man in the Holocene, 2004
97. David Hurn, Dae Hun Kwon, Rachmaninoff's, 2005

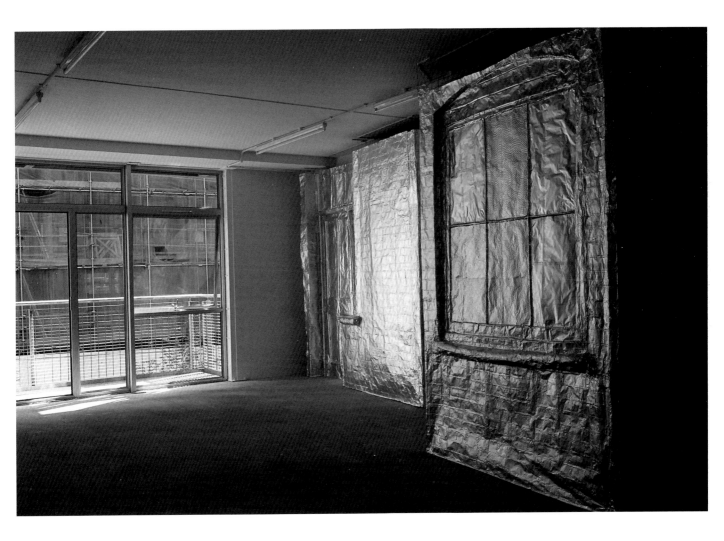

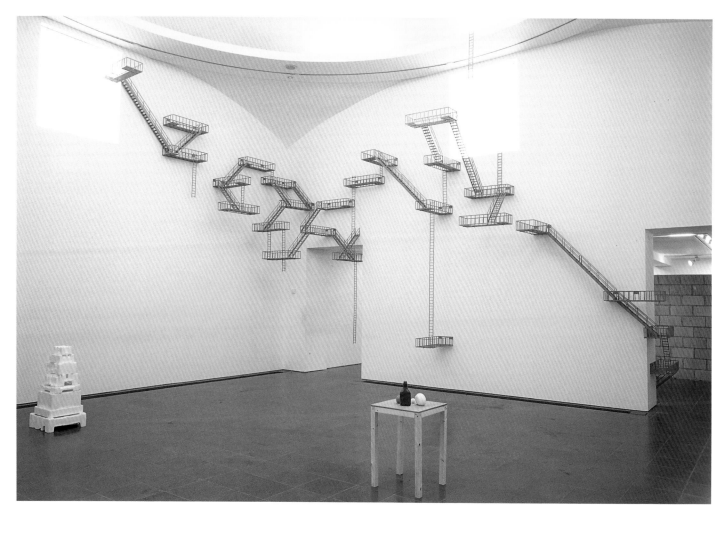

98. 'State of Play', Serpentine Gallery, 2004
99. Oliver Payne & Nick Relph,
'How to Recover from Hyper Mode', Millers Terrace, 2004

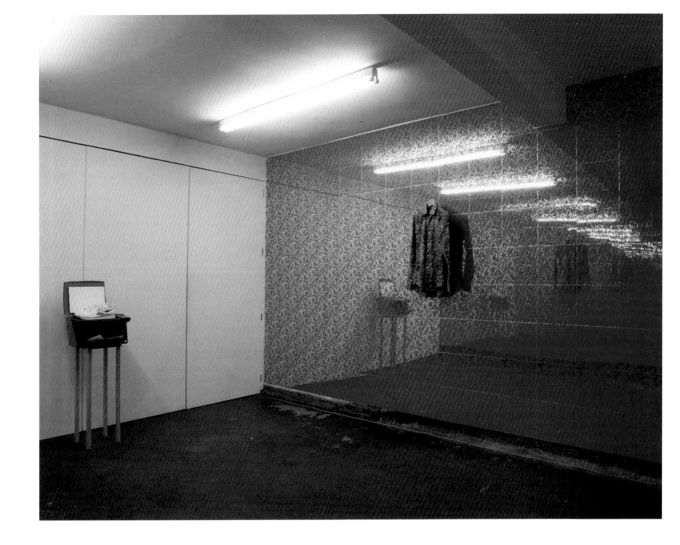

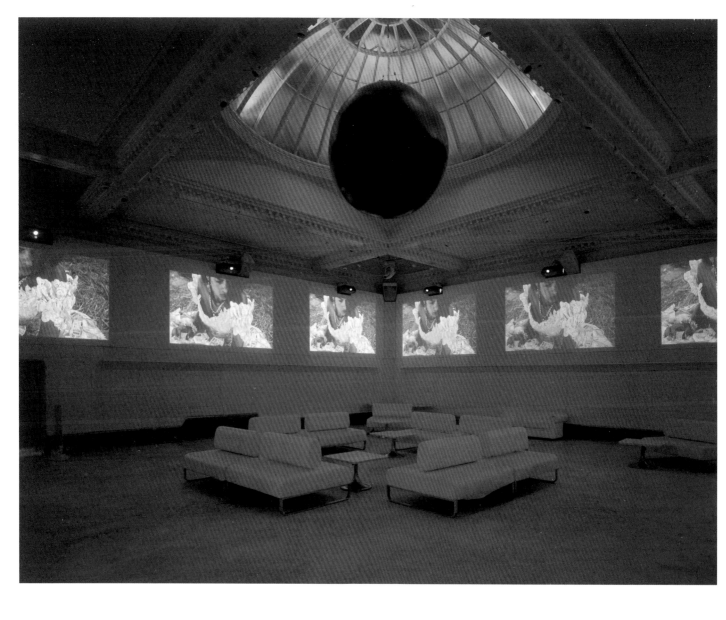

100. Tracey Emin, 'Can't See Past My Own Eyes', Sketch, 2004
101. Siobhan Hapaska, 'Playa de los Intranquilos', Peer, 2004

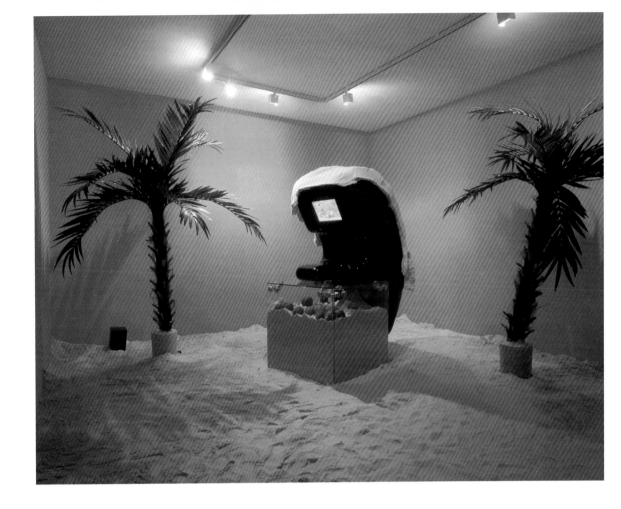

102. Seb Patane, *Ha Loo Sin Nation*, 31 March 2004,
'Alterity Display', Lawrence O'Hana Gallery
103. Joan Jonas, *Lines in the Sand*,
Tate Modern, 23 November 2004

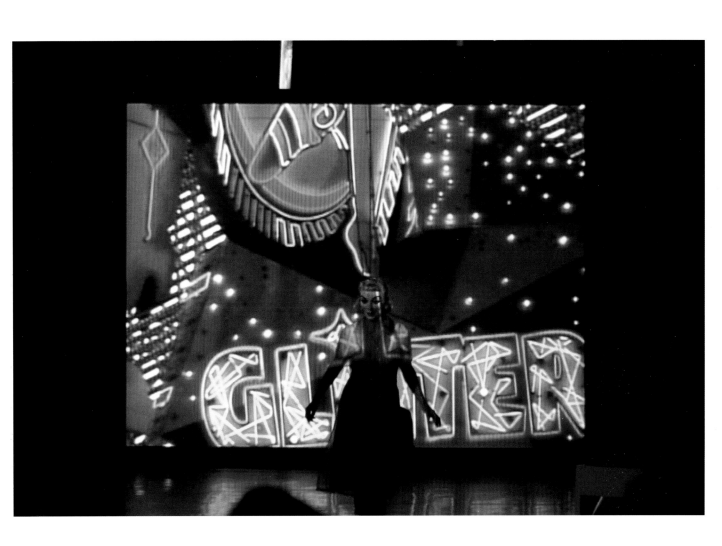

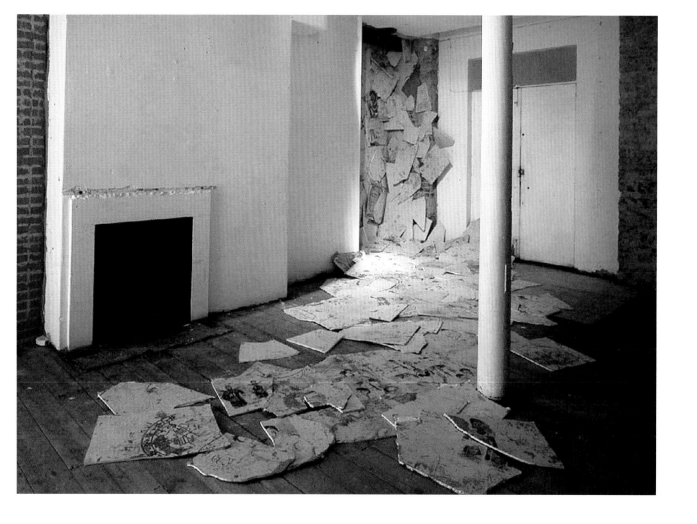

104. Maurizio Cannavacciuolo, 'Desecho',
Sprovieri project space, 2004
105. Marck Titchner, 'I WE IT',
Gloucester Road Tube Station, Platform for Art, 2004

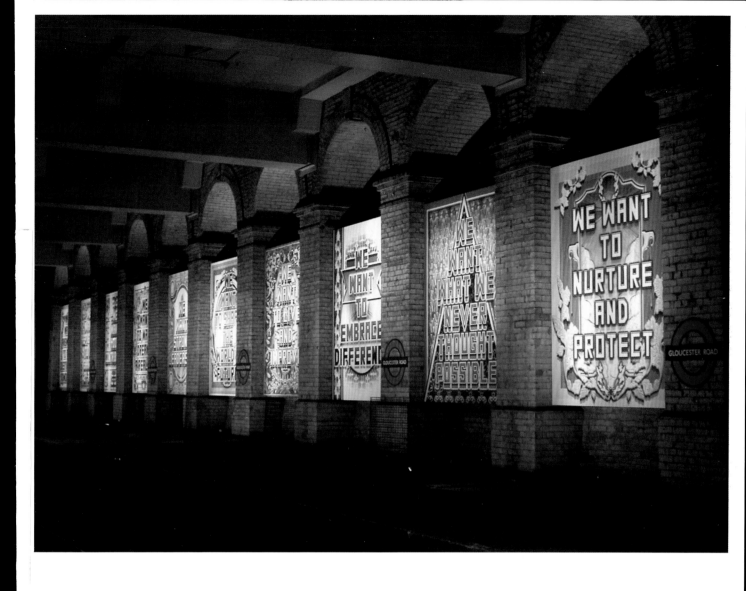

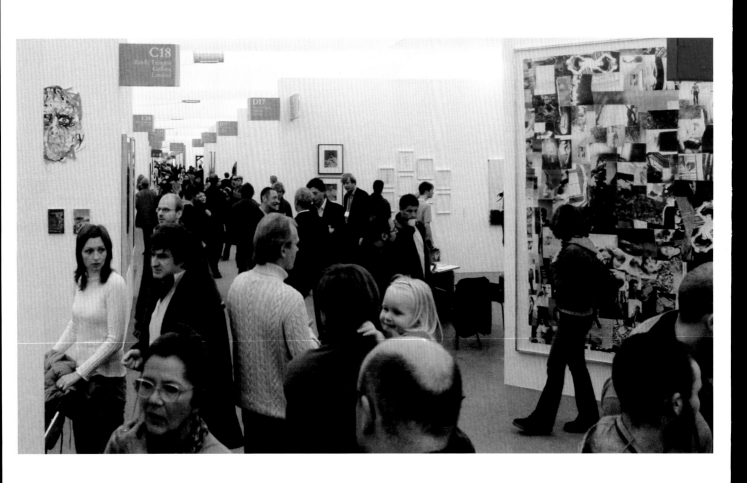

106. (left) Frieze Art Fair 2004, Regents Park, 2004
107. (right) Dustin Ericksen & Mike Rogers, *Cups*, HOTEL, 2005
108. (overleaf) Cerith Wyn Evans, *Rabbit Moon*,
Camden Arts Centre, 2004

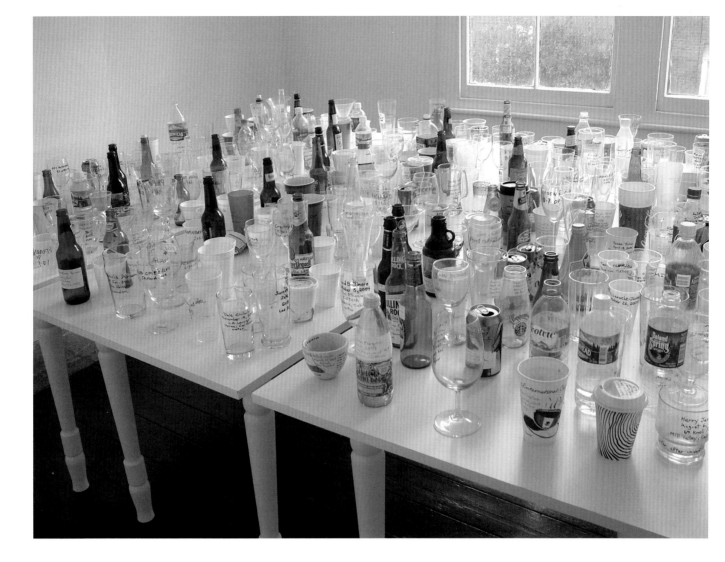

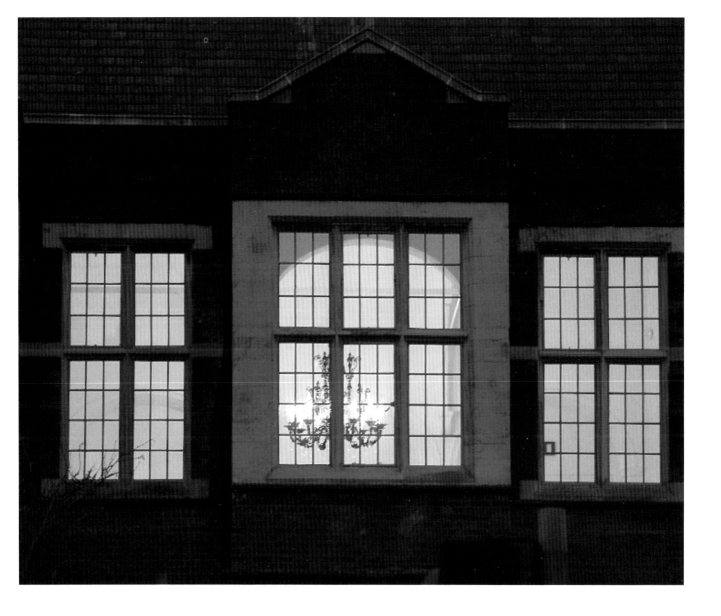

Credits

1. David Austen, 'Darkland', Peer,
2 September-18 October 2004. Courtesy: Peer, London

2. Nicole Wermers, 'Katzensilber', Millers Terrace,
22 May-20 June 2004. Courtesy: Herald Street, London.
Photograph: Luke Caulfield

3. 'Strange Weather', Modern Art,
9 July-15 August 2004. Courtesy: Modern Art, London
(Tom Burr, left, Philip Lai, right)

4. Roe Ethridge, 'County Line', greengrassi,
25 April-25 May 2005. Courtesy: greengrassi, London.
Photograph: Andy Keate

5. Don Brown, Sadie Coles HQ,
28 April-29 May 2004.
Courtesy: Sadie Coles HQ, London

6. George Brecht, 'Works from 1959-1973',
Gagosian Gallery, Heddon Street,
9 September-9 October 2004.
Courtesy: Gagosian Gallery, London

7. Glenn Brown, Serpentine Gallery,
14 September-7 November 2004. Sponsored by Hiscox.
Courtesy: Serpentine Gallery, London.
Photograph: Stephen White

8. Philip Guston, Timothy Taylor Gallery,
22 January-21 February 2004.
Courtesy: Timothy Taylor Gallery, London
and McKee Gallery, New York.
Copyright: Estate of Philip Guston

9. Roy Lichtenstein, 'Last Still Life',
Bernard Jacobson Gallery, 28 February-3 April 2004.
Courtesy: Bernard Jacobson Gallery, London

10. Valie Export, Camden Arts Centre,
10 September-31 October 2004.
Courtesy: Camden Arts Centre, London

11. Sherrie Levine, 'Loulou', Faggionato Fine Art,
21 April-8 June 2004. Copyright: the artist.
Courtesy: Faggionato Fine Art, London

12. 'Faces in the Crowd', Whitechapel,
3 December 2004-6 March 2005.
Courtesy: Idea Magazine London Borough of
Tower Hamlets. Photograph: Andy Wood

13. 'Paper', emilyTsingou gallery,
23 June-7 August 2004.
Courtesy: emilyTsingou gallery, London
(work by Dietmar Lutz)

14. 'DaDaDa: Strategies Against Marketecture',
temporarycontemporary,
22 October-21 November 2004.
Courtesy: temporarycontemporary, London

15. Sarah Morris, 'Los Angeles', White Cube,
3 June-10 July 2004. Copyright: the artist.
Courtesy: Jay Jopling/White Cube, London.
Photograph: Stephen White

16. Roy Lichtenstein, Hayward Gallery,
26 February-16 May 2004.
Courtesy: Hayward Gallery, London

17. 'Robert Mapplethorpe curated by David Hockney',
Alison Jacques Gallery, 14 January-12 March 2005.
Courtesy: Alison Jacques Gallery, London

18. 'The Black Album', Maureen Paley,
27 November 2004-23 January 2005.
Courtesy: Maureen Paley, London

19. Tom Gidley, STORE,
15 January-21 February 2004.
Courtesy: STORE, London

20. Julian Rosefeldt, 'New Works', MW Projects,
29 July-18 September 2004.
Courtesy: MW Projects, London

21. Lucy Skaer, 'The Problem in Seven Parts',
Counter Gallery, 18 March-24 April 2004.
Courtesy: Counter Gallery, London

22. Enrico David, 'Wizard's Sleeve', Cabinet,
13 May-11 June 2005. Courtesy: Cabinet, London

23. Olafur Eliasson, *The Weather Project*, Turbine Hall, Tate Modern, 16 October 2003-21 March 2004. Copyright: the artist and Tate, London 2004. Courtesy: the artist and neugerriemschneider, Berlin and Tanya Bonakdar Gallery, New York

24. Toby Paterson, 'After the Rain', The Curve, Barbican Art Gallery, 10 February-17 April 2005. Courtesy: the artist and The Modern Institute, Glasgow. Photograph: Lyndon Douglas

25. Simon Popper, 17 April 2004, part of 'Alterity Display', Lawrence O'Hana Gallery, 3 March-9 May 2004. Courtesy: Lawrence O'Hana Gallery, London

26. Till Exit, 'STRAND in several harmonies', i-cabin, 14 January-20 February 2005. Courtesy: i-cabin, London. Photograph: Sebastian Craig

27. Anri Sala, Hauser & Wirth London, 3 June-17 July 2004. Courtesy: the artist and Hauser & Wirth London

28. 'In the Palace at 4 am', Alison Jacques Gallery, 1-31 July 2004. Courtesy: Alison Jacques Gallery, London (shows Pablo Bronstein, fragment, left, Alessandro Raho, right)

29. Mark Leckey, *The Destructors*, Conway Hall, 8 July 2004. Part of 'Infra Thin Projects', curated by Mark Beasley and commissioned by Book Works. Photograph: Polly Braden

30. Beck's Futures 2004, ICA, 26 March-16 May 2004. Copyright: Marcus Leith. Courtesy: ICA, London

31. David Thorpe, Art Now, Tate Britain, 24 September-14 November 2004. Courtesy: Tate Britain, London. Photograph: Mark Heathcote

32. Camila Løw, Sutton Lane, 23 November-21 December 2004. Courtesy: Sutton Lane, London

33. Jason Martin, 'Day Paintings', Lisson Gallery, 21 April-22 May 2004. Courtesy: the artist and Lisson Gallery, London. Photograph: Dave Morgan

34. Lucy Gunning, 'Esc', Matt's Gallery, 21 April-13 June 2004. Courtesy: the artist and Matt's Gallery, London

35. Sol LeWitt, 'New Work', Lisson Gallery, 15 September-23 October 2004. Courtesy: the artist and Lisson Gallery, London. Photograph: Dave Morgan

36. Gary Webb, 'Deep Heat T-Reg Laguna', Chisenhale Gallery, 13 October-12 December 2004. Courtesy: Chisenhale Gallery, London. Photograph: Stephen White

37. Isa Genzken, 'Wasserspeier and Angels', Hauser & Wirth London, 21 April-22 May 2004. Courtesy: the artist and Hauser & Wirth London

38. Nate Lowman, 'Re: Re: Re: produce', Ritter/Zamet, 6 November-18 December 2004. Courtesy: Ritter/Zamet, London

39. Keith Coventry, 'New Works', Kenny Schachter Rove, 26 November-30 December 2004. Copyright: the artist. Courtesy: Kenny Schachter Rove, London. Photograph: Andy Keate

40. Lars Wolter, 'horizontals, verticals & vans', Rocket, 2 July-25 September 2004. Courtesy: Rocket, London

41. Stefan Kürten, 'Say Hello, Wave Goodbye', Thomas Dane, 3 February-19 March 2005. Copyright: the artist. Courtesy: Thomas Dane, London. Photograph: Thierry Bal

42. 'Animals', Haunch of Venison, 24 June-11 September 2004. Courtesy: Haunch of Venison, London (Mike Kelley, wall, Bojan Sarcevic, monitor)

43. Richard Hawkins, Corvi-Mora, 1-26 June 2004. Courtesy: Corvi-Mora, London

44. Lari Pittman, greengrassi, 7 October-13 November 2004. Courtesy: greengrassi, London. Photograph: Marcus Leith

45. Cy Twombly, 'Ten Paintings and a Sculpture', Gagosian Gallery, Britannia Street, 27 May-31 July 2004. Courtesy: Gagosian Gallery, London

46. 'Hou Bo & Xu Xiaobing, Mao's Photographers', The Photographers' Gallery, 8 April-30 May 2004. Courtesy: The Photographers' Gallery, London

47. Jason Meadows, Corvi-Mora, 17 November-18 December 2004. Courtesy: Corvi-Mora, London

48. Klaus Weber, 'Unfolding Cul-de-Sac', Cubitt, 8 April-23 May 2004. Courtesy: the artist and Cubitt, London

49. Tony Smith, 'Wall', Timothy Taylor Gallery, 9 September-9 October 2004. Courtesy: Timothy Taylor Gallery, London and Matthew Marks Gallery, New York. Copyright: Estate of Tony Smith

50. 'Her Kind', The Approach, 8 July-8 August 2004. Courtesy: The Approach, London

51. 'Meet You At The Corner', FORTESCUE AVENUE / Jonathan Viner, 15 April-29 May 2005. Courtesy: FORTESCUE AVENUE / Jonathan Viner, London

52. 'Trailer', Man in the Holocene, 11 September-10 October 2004. Courtesy: Man in the Holocene, London

83. Pae White, *Rover Momentum*, 15-18 October 2004. Commissioned by Frieze Art Fair 2004, produced in collaboration with Rover. Photograph: Getty Images

84. Keith Wilson, 'z is for ziggurat', One in the Other, 24 October-7 December 2003. Courtesy: One in the Other, London

85. Pablo León de la Barra, *Public Library*, part of 'Publish and Be Damned', Cubitt, 8 July-1 August 2004. Courtesy: the artist and Cubitt, London

86. Inventory, 're:presentations of everyday life', The Approach, 17 January-15 February 2004. Courtesy: The Approach, London

87. Adam Chodzko, *Night Shift* (from *Design for a Carnival*), 15-18 October 2004. Commissioned and produced by Frieze Art Fair 2004. Photograph: Polly Braden

88. Naomi V Jelish, curated by John Ivesmail, presented by Jamie Shovlin, Riflemaker, 21 May-26 June 2004. Courtesy: Riflemaker, London

89. '100 Artists See God', ICA, 19 November 2004-9 January 2005. Copyright: Will Cunningham. Courtesy: ICA, London

90. Ángela de la Cruz, Lisson Gallery, 5 June-3 July 2004. Courtesy: the artist and Lisson Gallery, London. Photograph: Stephen Willats

91. Gregor Schneider, *Die Familie Schneider*, undisclosed location in the East End, 2 October-23 December 2004. Commissioned and produced by Artangel. Photograph: Thierry Bal

92. Sophie von Hellermann, 'On the Ground', Vilma Gold, 15 January-15 February 2004. Courtesy: the artist and Vilma Gold, London

93. 'Concert in the Egg', The Ship, 10 April-9 May 2004. Courtesy: The Ship, London

94. Luke Gottelier, 'Early Paintings', week 3 of 'Quarters', Whitechapel Project Space, 4-28 March 2004. Courtesy: Whitechapel Project Space, London

95. Deborah Castillo, 'South American Cleaner', White Cubicle – 24/7 Toilet Gallery, The George and Dragon, 25 January 2005. Courtesy: 24/7, London

96. 'Fee of Angels', Man in the Holocene, 26 November 2004-15 January 2005. Courtesy: Man in the Holocene, London (shows Roger Hiorns)

97. David Hurn, Dae Hun Kwon, Rachmaninoff's, 22 June-24 July 2005. Courtesy: Rachmaninoff's, London (shows Dae Hun Kwon)

98. 'State of Play', Serpentine Gallery, 3 February-28 March 2004. Sponsored by Hugo Boss. Courtesy: Serpentine Gallery, London

99. Oliver Payne & Nick Relph, 'How to Recover from Hyper Mode', Millers Terrace, 15 October-28 November 2004. Courtesy: Herald Street, London. Photograph: Andy Keate

100. Tracey Emin, 'Can't See Past My Own Eyes', Sketch, 25 May-10 July 2004. Courtesy: Jay Jopling/White Cube, London. Photograph: Stephen White

101. Siobhan Hapaska, 'Playa de los Intranquilos', Peer, 20 May-4 July 2004. Courtesy: Peer, London

102. Seb Patane, *Ha Loo Sin Nation*, 31 March 2004, part of 'Alterity Display', Lawrence O'Hana Gallery, 3 March-9 May 2004. Courtesy: Lawrence O'Hana Gallery, London

103. Joan Jonas, *Lines in the Sand*, Tate Modern, 23 November 2004. Courtesy: Tate Modern, London. Photograph: Sheila Burnett

104. Maurizio Cannavacciuolo, 'Desecho', 15-17 October 2004, Sprovieri project space. Courtesy: Pescali & Sprovieri, London. Photograph: Matthew Hollow

105. Mark Titchner, 'I WE IT', Gloucester Road Tube Station, 22 January-19 April 2004. Copyright: the artist. Commissioned by Platform for Art, London Underground, 2004

106. Frieze Art Fair 2004, Regents Park, 15-18 October 2004. Courtesy: Frieze Art Fair, London

107. Dustin Ericksen & Mike Rogers, *Cups*, HOTEL, 30 January-6 March 2005. Courtesy: the artists and HOTEL, London

108. Cerith Wyn Evans, *Rabbit Moon*, Camden Arts Centre, 31 January-11 April 2004. Courtesy: Camden Arts Centre, London. Photograph: Raymond Williams

Pablo Lafuente is the Managing Editor of *Afterall*, a semi-annual
art journal published by Central Saint Martins College of Art & Design
and California Institute of the Arts. He contributes regularly to *Art Monthly*,
ArtReview, *Flash Art* and *frieze*, and occasionally curates. He is currently
researching for a philosophy PhD at Middlesex University, London.

Additional research by Matt Packer.

The author and the publishers would like to thank all the galleries, organisations
and individuals who provided material for the book, all the artists and photographers
who allowed us to reproduce their work, and all the people who helped with their
advice and support.